ADORABLE ART CLASS

A Complete Course in Drawing Plant, Food, and Animal Cuties

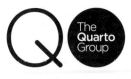

Inspiring | Educating | Creating | Entertaining

Brimming with creative inspiration, how-to projects, and useful information to enrich your everyday life, quarto.com is a favorite destination for those pursuing their interests and passions.

First published in 2023 by Rock Point, an imprint of The Quarto Group,
142 West 36th Street, 4th Floor, New York, NY 10018, USA
T (212) 779-4972 F (212) 779-6058 www.Quarto.com

Rock Point titles are also available at discount for retail, wholesale, promotional, and bulk purchase. For details, contact the Special Sales Manager by email at specialsales@quarto.com or by mail at The Quarto Group, Attn: Special Sales Manager, 100 Cummings Center Suite 265D, Beverly, MA 01915 USA.

Library of Congress Cataloging-in-Publication Data

Names: Rodgers, Jesi, author, illustrator.
Title: Adorable art class : a complete course in drawing plant, food, and
 animal cuties : includes 75 step-by-step tutorials / Jesi Rodgers.
Description: New York : Rock Point, [2023] | Summary: "Adorable Art Class
 is your step-by-step guide to creating super-cute illustrations of
 everyday objects using a range of techniques and mediums, from pencil
 sketching to marker coloring" -- Provided by publisher.
Identifiers: LCCN 2022021642 (print) | LCCN 2022021643 (ebook) | ISBN
 9781631068690 (trade paperback) | ISBN 9780760376423 (ebook)
Subjects: LCSH: Plants in art. | Food in art. | Animals in art. |
 Drawing--Technique.
Classification: LCC NC805 .R63 2023 (print) | LCC NC805 (ebook) | DDC
 741.2--dc23/eng/20220621
LC record available at https://lccn.loc.gov/2022021642
LC ebook record available at https://lccn.loc.gov/2022021643

10 9 8 7 6 5 4 3 2 1

ISBN: 978-1-63106-869-0

Publisher: Rage Kindelsperger
Creative Director: Laura Drew
Managing Editor: Cara Donaldson
Project Editor: Sara Bonacum
Editorial Assistant: Katelynn Abraham
Cover and Interior Design: Kim Winscher

Printed in China

ADORABLE ART CLASS

A Complete Course in Drawing Plant, Food, and Animal Cuties

INCLUDES 75 STEP-BY-STEP TUTORIALS

JESI RODGERS

ROCK POINT

CONTENTS

Introduction

Hey, hi!

My name is Jesi, but online I go by Jesiiii; that's four i's to represent my four eyes. (I proudly wear glasses!) I am an illustrator, painter, and product designer of what I like to call "quirky art for happy hearts." We all have the special gift of creativity, but when it comes to my creative process, often a funny play on words or a pun will spark inspiration for the silly things I love to draw. I enjoy using bold lines and saturated colors in my work, and never shy away from adding a little sparkle when I can.

I'm so excited to share my artistic style with you!

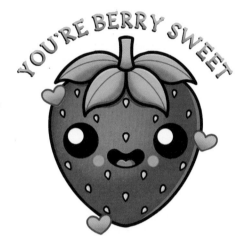

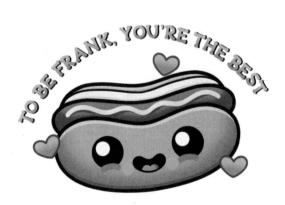

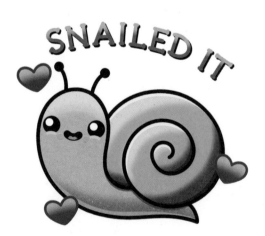

Tools

The best thing about making art is that you can pick whatever medium works for you. For the basics, I recommend starting with a nice drawing pad and graphite drawing pencils. When you start a character, sketch out your design lightly in your drawing pad first.

Don't shy away from using other drawing tools to help perfect your work. I love using rulers for straight lines and circle tools to make perfect curves. Ink the lines with different sized graphic pens. Use a medium-tip pen for the outlines and a thin-tip pen for all the itty-bitty details. Once the ink is set, lightly erase whatever pencil marks are still showing. And now the really fun part—COLOR! Feel free to experiment, explore, and find your own creative style. Markers, colored pencils, or even watercolor paints are a great place to start. Alternatively, you could scan your drawing in order to color it in digitally on your computer.

Tips & Tricks

Not all of the designs in this book are symmetrical but many are. One way to ensure symmetry is to draw a line down the middle of the design to make sure both sides match up perfectly. You can also fold the paper in half and trace a flawlessly matching side to the drawing.

Adding a face to your drawing will give it some personality. Try different expressions to convey a mood. Is your character happy with a smile? Maybe they're feeling spunky with a wink and tongue out, or feeling in love with heart-eyes, or maybe they're just a little sad with tears welling up in their adorable eyes.

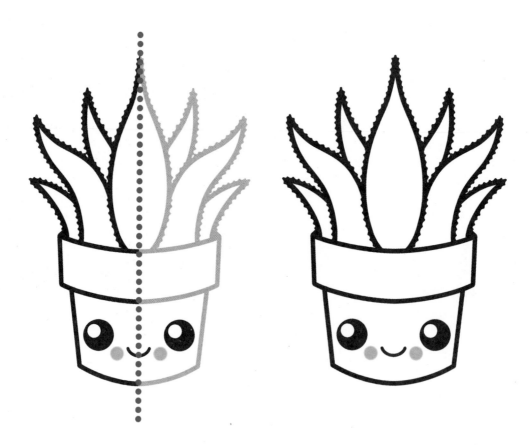

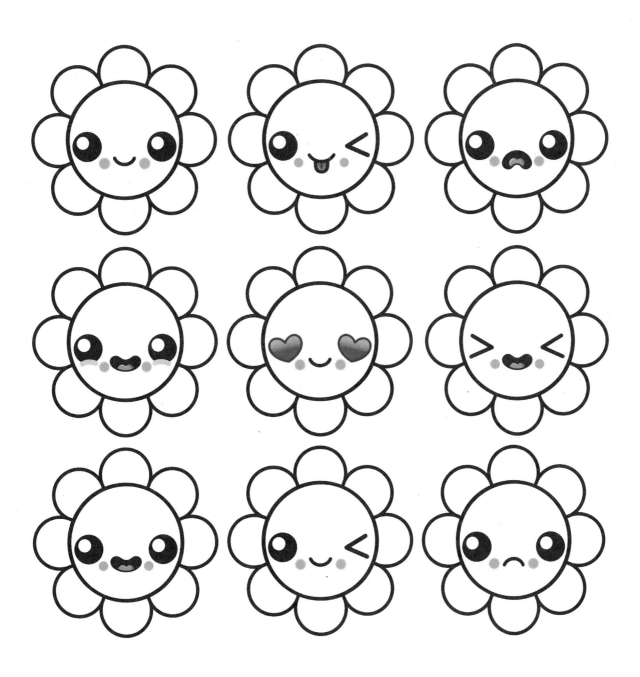

Don't be afraid to play around with where you put the face on the drawing. Make the face bigger or smaller, on the top, middle, or bottom of the design. The options are endless!

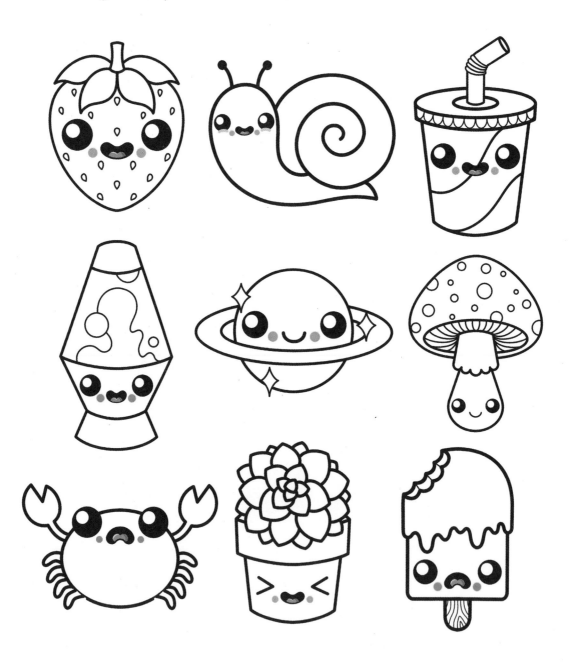

You can even add multiple faces to a character to turn a drawing into several characters at once.

Even though I am guiding you through your learning process, these drawings are uniquely yours. If your quirky, creative heart pulls you to make something square instead of round, add a face or two, or even create a blue strawberry rather than a red one, trust your instincts. There is no right way to express yourself. Use the blank characters at the end of the tutorials to practice different facial expressions and play with various bold colors. Practice your techniques with the dot grid pages at the end of the book.

Now, grab your tools and let's have some *pun*!

FOOD
&
DRINK

Cupcake

1 Starting with the cupcake liner, draw a wide U shape with a curve for the base and the sides slightly extending out.

2 Across the top of the liner, draw a line with curved ends that extend past the sides. Add three jagged points, like little mountains, to the center of this line.

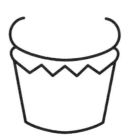

3 Now it's time to add the thick frosting swirls! Draw an incomplete oval the width of the cupcake liner.

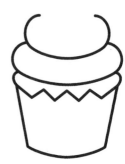

4 Draw a smaller incomplete oval above the first one, making sure to leave a proper amount of space to show the thickness of the swirls.

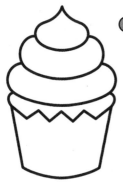

5 Top the cupcake with a nice dollop of frosting that looks like a chocolate kiss.

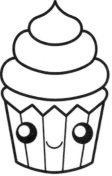

6 Give the cupcake liner its pleats by drawing four slanted lines that extend from the downward jagged points. The two lines on the left should slant right and the two lines on the right should slant left. Finally, add the face, color, and embellishments. Don't forget the sprinkles!

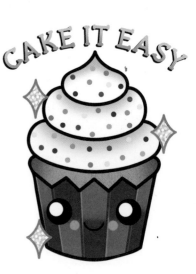

CAKE IT EASY

Taco

 1 Starting with the taco shell, draw the top of a semicircle.

 2 Connect the left side of the opened semicircle with a curved line that straightens and extends below and just past the right side.

 3 On the right side of the semicircle, draw a small, curved line that extends just past the bottom line.

 4 Curve the bottom line of the taco shell up to just past the center of the top of the first semicircle to form the backside of the taco shell.

 5 Add in the fillings! For the meat, close the small curve at the bottom with a jagged line. For the sour cream, draw another jagged line of the same width on top.

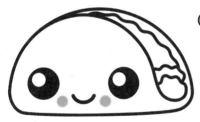 **6** For the final fillings, draw a wavy, arched line on top of the sour cream to the top of the first semicircle. Finally, add the face, color, and embellishments.

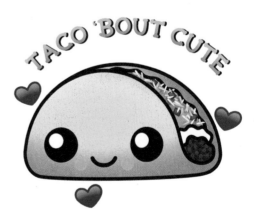

TACO 'BOUT CUTE

Ice Cream Cone

1 Starting with the cone, draw a short, wide U shape with a curved line for the base and the sides slightly extending out.

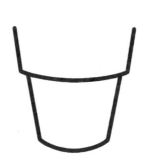

2 Draw another U shape below this one that is narrower and taller for the base of the cone.

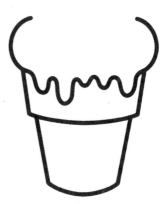

3 Moving on to the soft-serve ice cream, draw a line with curved ends that extend past the sides of the cone, adding ice cream drips of varying lengths along the cone.

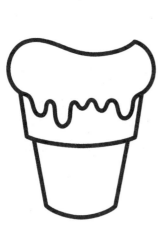

4 Connect the curved ends with a nice, swirled line.

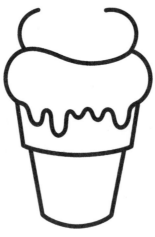

5 Start a narrower swirl of ice cream on top of the first one.

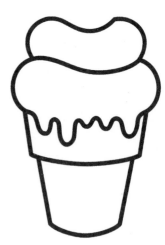

6 Connect the curved ends with another nice, swirled line.

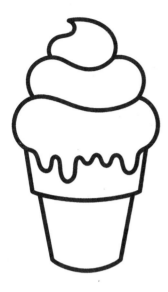

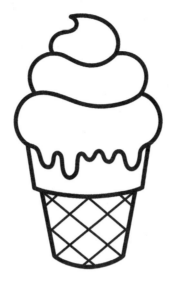

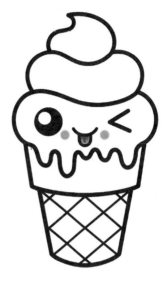

7 Top the ice cream with a final dollop that looks like a rounded chocolate chip.

8 Add a waffle pattern to the cone with crisscrossing lines.

9 Finally, add the face, color, and embellishments.

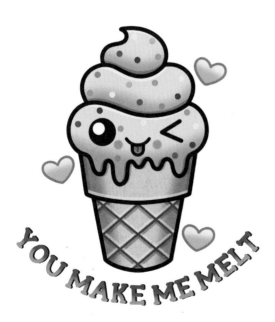

DECORATE IT!

DECORATING IS THE FUN PART! GRAB A BUNCH OF YOUR MOST VIBRANT COLORS, AND IN DOTS OF VARYING SIZES, ADD ALL THE SPRINKLES.

Hamburger

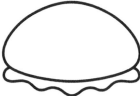
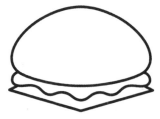
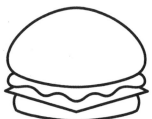

1. Starting with the top bun, draw a slightly arched semicircle, with the ends curving in.

2. Connect the ends with a curved line. For the lettuce, draw a wavy line below and connect to the bun with curved ends.

3. Next, the cheese. Starting at the curved ends of the lettuce, draw two short line pointing outward on either side. Connect with a wide V.

4. Below the cheese, draw a line with curved ends narrower than the cheese for the meat patty.

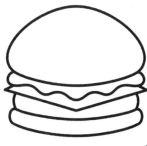

5. Below the meat patty, draw a curved line with curved ends slightly wider than the meat patty for the bottom bun.

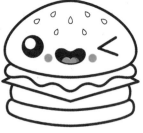

6. Finally, add a face, color, and embellishments.

YOU'RE THE ONLY BUN FOR ME

Fries

1. Starting with the cup, draw a wide U shape with a curved line for the base and the sides slightly extending out.

2. Connect the sides with two short lines slanting inward. Then, connect the slanted lines with the bottom of a semicircle.

3. Time for the fries. For the first fry, draw two lines slanted left coming out of the cup. Connect the top at an angle. Then, draw a line down the center of the fry.

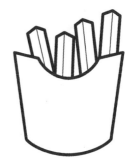

4. Repeat step 3 and draw three more fries leaning different ways in the cup.

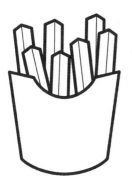

5. Repeat step 4 but place the taller fries behind the first layer of fries.

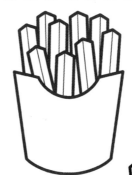

6. Repeat step 5, placing a third layer of fries behind the second.

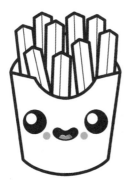

7. Finally, add a face, color, and embellishments.

I ONLY HAVE FRIES FOR YOU

FOOD & DRINK 19

Popcorn

1 Starting with the popcorn cup, draw a tall U shape with a curved line for the base and the sides slightly extending out.

2 Connect the sides with a scalloped line, leaving the two ends as half-scallops.

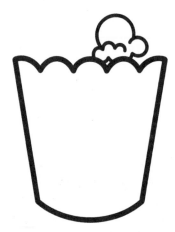

3 Add the popcorn! Starting above the rightmost scallop, draw three connected scallops facing the opposite way, with the ends curved in. Add two smaller scallops to the left side moving inward, facing the opposite direction. Draw a large semicircle on top for the main kernel of the popcorn.

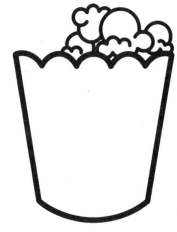

4 Draw two more smaller popcorns on either side of the first one. Then, add one popcorn in the space between the leftmost and first popcorn, but upside-down.

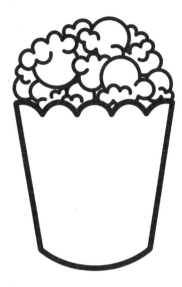 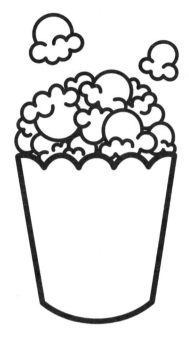 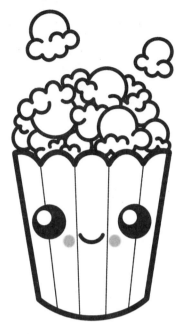

5 Fill the top of the popcorn cup and create a mound of popcorn.

6 Add two pieces of popcorn floating slightly above the popcorn mound on the left and right sides.

7 Give the popcorn cup pleats by drawing four slanted lines downward from the four points of the scallops. Finally, add the face, color, and embellishments.

HOPE YOUR DAY IS POPPIN'

DECORATE IT!

OMBRÉ IS A FRENCH WORD THAT REFERS TO COLORS THAT FADE FROM DARK TO LIGHT. USE AN OMBRÉ EFFECT WHEN YOU COLOR TO ADD DEPTH AND INTEREST.

Soda

1. Starting with the lid of the cup, draw a narrow horizontal oval.

2. Below, draw a curved line with straight sides connecting to the oval.

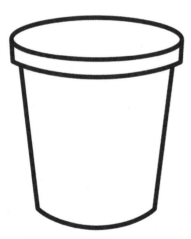

3. For the cup, draw a tall U shape with a curved base and the sides slightly extending out.

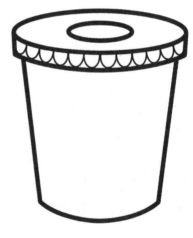

4. Back to the lid, draw a smaller oval in the center. Then, add scallops on the rim of the lid.

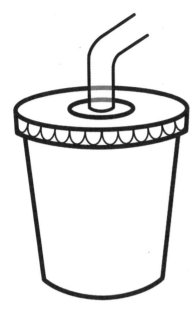 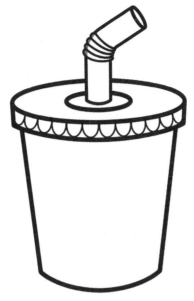 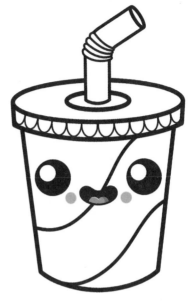

5 For the straw, start with a curved line in the center of the smaller oval. Extend two vertical lines from each end of the curved line. Curve both lines slightly right, keeping them parallel to each other.

6 Close the end of the straw with a narrow oval. Then, create pleats with four thin, slightly slanted ovals, to the curve of the straw, thinner on the right side and getting wider on the left.

7 Finally, add a face, color, and embellishments.

YOU ARE SODA-NG CUTE

DECORATE IT!

A SECOND STEP AFTER COLORING WOULD BE ADDING TEXT. THESE CUTE TAGLINES ARE JUST SUGGESTIONS. FEEL FREE TO COME UP WITH SOME PUNS OF YOUR OWN.

Hot Dog

1. Starting with the front bun, draw an oval with a single dip in the center on the top.

2. Add the hot dog on top by following the curve of the bun, but slightly longer than the bun.

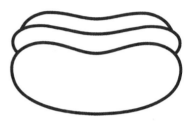

3. Following the same curve, add the back bun on top, narrower than the hot dog.

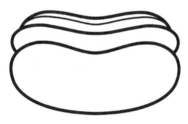

4. To add dimension, draw a thin line with the same curve through the back bun, closer to the top line.

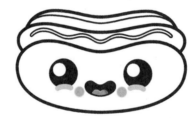

5. Finally, add a face, color, and embellishments. Don't forget the mustard!

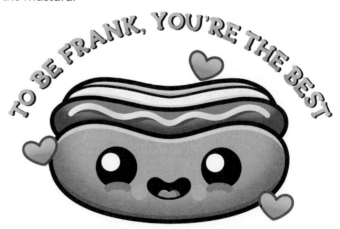

TO BE FRANK, YOU'RE THE BEST

Cereal

1. Starting with the bowl, draw the bottom of a wide semicircle.

2. Connect the sides with a slightly arched line.

3. Next, draw an oval inside the top half of the bowl. Be sure to leave a thin space on top for the rim.

4. For the milk, draw a curved line from left to right, going up and past the outer rim. Then, draw a wavy line with three curves, connecting back down to the inside of the bowl. Add a circle floating off of the milk for a drop of milk.

5. In the left side of the milk, draw a short, wavy line slanted to the left. Then, extend a slanted oval handle with straight sides and a wider end.

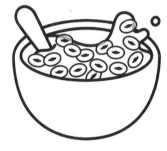

6. Add small oval disks in the milk with shaded centers for the cereal.

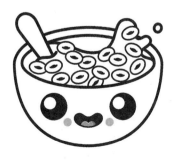

7. Finally, add a face, color, and embellishments.

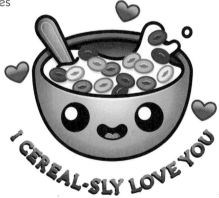

I CEREAL-SLY LOVE YOU

Waffle

① Start with a circle.

② Draw a slightly smaller circle inside the first circle to create a thin rim.

③ Inside the circle, add the crosshatch of the waffle with three lines crossing opposite ways.

④ Then, draw the same crosshatch, but slightly above the first.

⑤ Next, erase the places in the crosshatch where the lines intersect to create the waffle pockets.

⑥ At the top of the waffle, draw a wavy blob of maple syrup.

⑦ Finally, add a pat of butter, a face, color, and embellishments.

I LOVE YOU A WAFFLE LOT

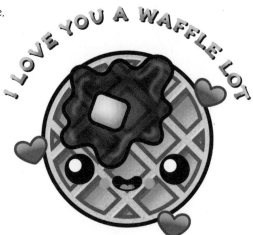

Donut

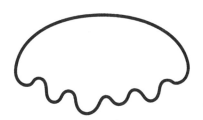

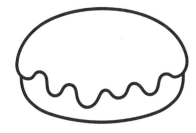

① Start by drawing the top of a short, wide semicircle.

② Next, connect the sides with a wavy line of dripping icing.

③ Below the icing, draw a curved line connecting to the edges of the icing.

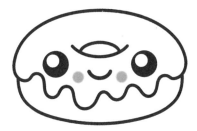

④ For the donut hole, draw the top of a small semicircle. Connect the sides with a curved line extending wider than the top. Finally, add a face, color, and embellishments.

DONUT WORRY, BE HAPPY

Cherry Pie

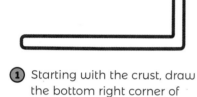

1 Starting with the crust, draw the bottom right corner of a rectangle. Draw a second line inside of the first and connect at the left corner, leaving the top right open.

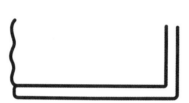

2 On the left, connect a wavy line for the left side of the rectangle.

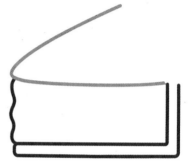

3 Then, on top, draw a faint V shape starting from the inner right line with the point touching the left side. Extend the top side slightly out.

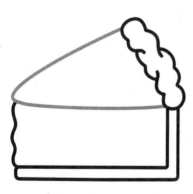

4 For the top crust, connect the V with a wavy oval thicker than the right side of the rectangle.

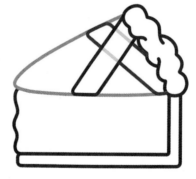

5 Next, draw the lattice crust on top. Start with a slightly slanted rectangle strip crossing beneath the wavy pie crust. Then, overlap another strip slanting the opposite way from the far corner of the pie down toward the base.

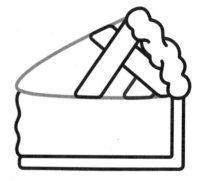

6 Touching the first strip and the top of the pie, draw a triangle, leaving space between the second strip.

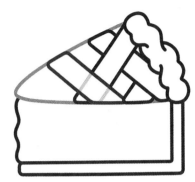

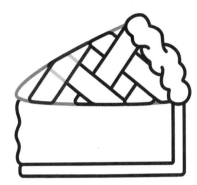

⑦ At the middle of the V, draw another strip parallel to the first strip and overlapping the second.

⑧ Below the end of the first strip, draw another strip parallel to the one extending from the top right corner and touch the base.

⑨ At the point of the pie, draw a sliver of a strip in the shape of the point parallel to the first strip.

⑩ Make sure to erase the places where the lattice strips cross over each other. Then, connect the wavy left side of the base to the right with a wavy line of dripping filling.

⑪ Finally, add a face, color, and embellishments.

YOU ARE A CUTIE PIE

DECORATE IT!

WHEN ADDING DETAILS TO YOUR CHARACTER, YOU DON'T ALWAYS HAVE TO BE SUPER SPECIFIC. SOMETIMES, JUST AN IMPRESSION OF A DETAIL MAKES YOUR CHARACTER VISUALLY INTERESTING, LIKE DIFFERENT COLORED CIRCLES THAT IMPLY CHERRIES!

1 Starting with the glass, draw a tall U shape.

2 Connect the sides with a slightly arched line.

3 Next, draw an oval inside the top of the glass.

4 For the stem of the glass, draw two curved lines extending wider at the bottom. Then, draw a circle around the stem narrower than the glass.

5 Adding the first dollop of whipped cream, draw an incomplete oval the width of the inner oval. Erase any overlapping lines.

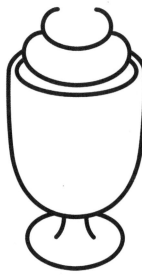

6 Draw a smaller incomplete oval above the first one, making sure to leave a proper amount of space to show the thickness of the whipped cream.

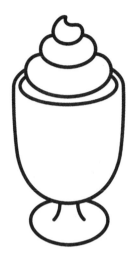 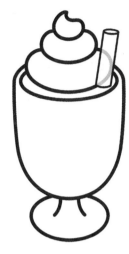 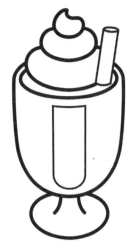 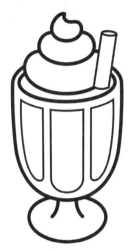

⑦ Top the milkshake with a nice dollop of whipped cream that looks like a rounded chocolate chip.

⑧ Add the straw with a rectangle slanting right in front of the whipped cream. Connect the top end with an oval.

⑨ For the surface of the glass, in the center draw a tall, thin U with a straight line connecting the top.

⑩ On either side of the center panel, draw similar panels that follow the curves of the glass.

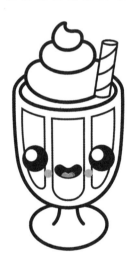

⑪ Finally, add a face, color, and embellishments.

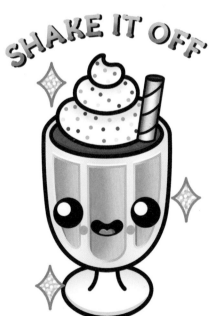

SHAKE IT OFF

DECORATE IT!

A COLORFUL STRAW CAN MAKE A DRINK TASTE GREAT WHILE LOOKING FUN. FOR A CLASSIC LOOK, COLOR EVERY OTHER PANEL OF THE STRAW TO CREATE A SPIRAL EFFECT.

Gumballs

(1) Start with the globe of the gumball machine by drawing a circle.

(2) At the bottom of the circle, draw two lines extending slightly out on either side. Connect with a curved line.

(3) Below the curved base, connect a similar curved line with rounded ends slightly wider.

(4) Next, inside the top of the globe, draw the bottom of a small semicircle. Connect an arch on top. Then, draw a little circle half inside the arch. Erase any overlapping lines.

 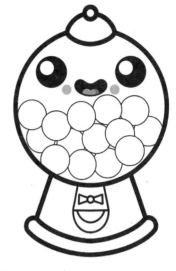

⑤ In the base of the container, draw a small square at the top with the sides extending slightly out. Draw a tiny bowtie inside for the knob.

⑥ Below the square, draw the bottom of a semicircle the same width. Inside, draw a smaller semicircle.

⑦ Finally, add a face, color, and embellishments.

I CHEWS YOU

DECORATE IT!

YOU MIGHT NOT USE THE WHITE PENCIL OFTEN, BUT IT COMES IN HANDY FOR ADDING DIMENSION. SHADE THE CENTER OF THE GUMBALL MACHINE, REMEMBERING THE TOP PIECE, TO CREATE THE EFFECT OF LIGHT BOUNCING OFF OF IT.

Popsicle

1) Starting with the popsicle, draw the sides and base of a rectangle.

2) Connect the sides with an arch.

3) For the popsicle stick, attach a short, narrow U to the bottom of the rectangle.

4) On the top left corner of the popsicle, draw four scallops curving inward to make a bite. Erase any outside lines.

5) From the top point of the bite, draw a curved line tracing the outside of the popsicle ending halfway down the right side. Then, draw a short line from the bottom point of the bite on the left side ending parallel to the right. Erase the original lines now inside the new lines.

(6) Connect the sides with a wavy line of popsicle drips.

(7) Back to the bite, connect the outside of the scallops together with shallower scallops, making sure to leave space between. Draw three lines to connect the points to each scallop.

(8) Finally, add a face, color, and embellishments.

DECORATE IT!

FOR AN EASY WOOD-GRAIN EFFECT, DRAW A COMBINATION OF CONCENTRIC OVALS AND WAVY LINES CURVING INWARD FROM THE SIDES. DON'T WORRY ABOUT STRAIGHT OR SMOOTH LINES.

JUST CHILL OUT

Juice Box

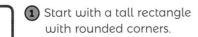

① Start with a tall rectangle with rounded corners.

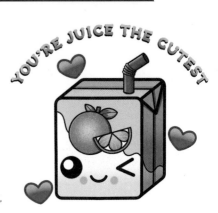

YOU'RE JUICE THE CUTEST

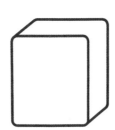

② From the top left corner, draw a line slanting slightly right. Connect with a line parallel to the top of the rectangle and following the curve down the right side. Then, connect another line, slanted to the left, to the bottom right corner of the rectangle.

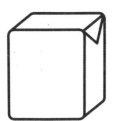

③ In the gap between the top right corners, connect a triangle the width of the side pointing down.

④ Then, draw a center line across the top, crossing through the triangle, and down the side of the juice box.

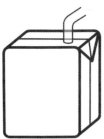

⑤ For the straw, on top in the front right side of the juice box, draw two lines curving to the right. Connect the base with a curved line.

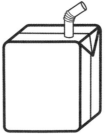

⑥ Connect the top ends of the straw with a thin oval. Then, add four thin, curved ovals to the bend of the straw, narrower on the right and getting wider left.

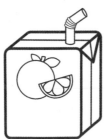

⑦ Draw some designs of an orange and orange slice on the front of the box.

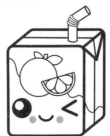

⑧ Finally, add a diagonal wavy line, a face, color, and embellishments.

Snow Cone

1. Starting with the cone, draw a V shape with slightly curved sides.

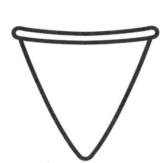

2. Then, connect the sides with a thin oval with a curved top and base slightly wider than the cone.

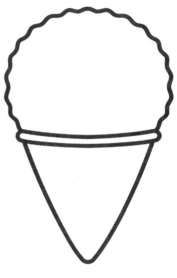

3. Above, draw a slightly wider semicircle with a wavy line.

4. Finally, add a face, color, and embellishments.

I LOVE YOU SNOW MUCH

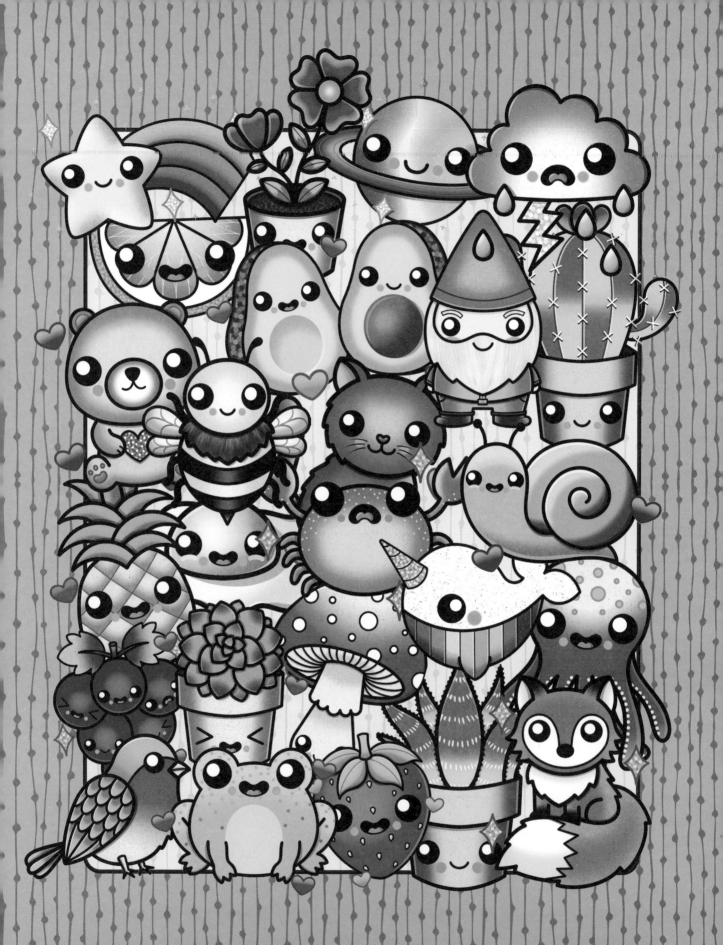

Natural World

Mushroom

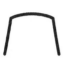

① Starting with the stem, draw an upside-down U shape with a curved line at the top and the sides slightly extending out.

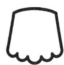

② Connect the sides with a scalloped line that moves from being short to long on each side

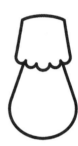

③ Complete the stem by drawing a lightbulb shape from the scalloped line.

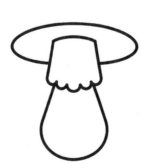

④ Moving on to the cap, draw an oval from the middle of one of the sides of the upper part of the stem to the other side.

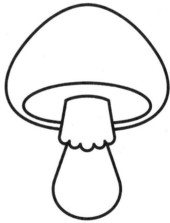

⑤ Starting slightly below the oval, draw a nice bulbous shape for the outer part of the cap.

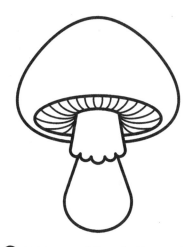

6 Add curved lines to the oval shape for the gills.

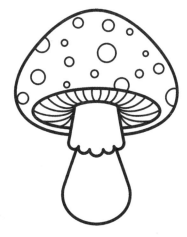

7 Give your mushroom cap spots by drawing small circles of varying sizes.

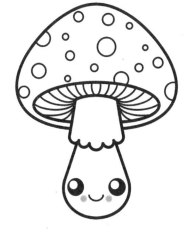

8 Finally, add a face, color, and embellishments.

DECORATE IT!

USE VARYING SHADES OF THE SAME COLOR FOR SOME DEPTH IN ANY DESIGN YOU CREATE. ON THE GILLS OF THE MUSHROOM, USE A DARKER SHADE NEAR THE CENTER, COLORING AROUND THE STEM AT EQUAL DISTANCES. BLEND INTO THE LIGHTER SHADES AS YOU MOVE OUTWARD.

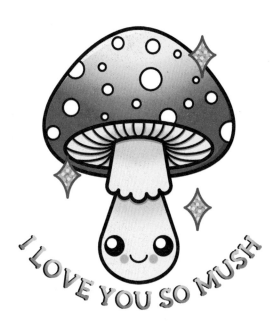

I LOVE YOU SO MUSH

Strawberry

1. Starting with the stem, draw a vertical shape like a narrow hourglass.

2. Draw two leaves that connect to each other off the stem. Give them pointed tips.

3. Draw two more leaves "behind" the first two leaves.

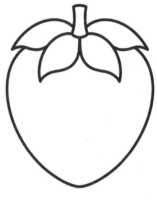

4. Moving on to the fruit part, draw a bulbous V shape.

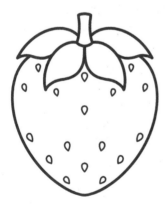

5. Give the strawberry its seeds by drawing tiny, rounded triangles for each one.

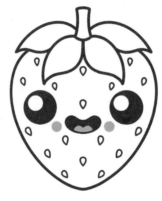

6. Finally, add a face, color, and embellishments.

YOU'RE BERRY SWEET

Avocado

1. Starting with the top of the avocado, draw an arch with the sides extending slightly out.

2. Connect the sides with the bottom of a semicircle slightly wider than the top arch, with the sides curving in where they connect to the arch.

3. Draw a small circle in the bottom for the pit.

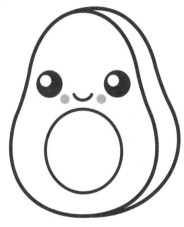

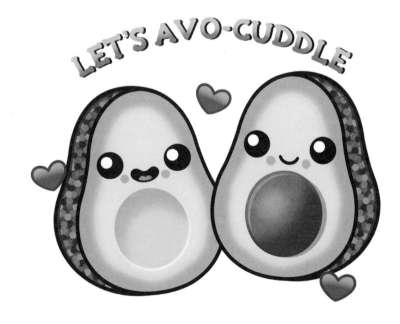

LET'S AVO-CUDDLE

4. For dimension, draw a curved line from the top that follows the curve of the right side to the base. Finally, add a face, color, and embellishments.

Orange Slice

1 Start with drawing the bottom of a semicircle.

2 Connect the top with a straight line.

3 Inside, draw a smaller U connecting to the top.

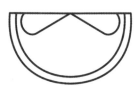

4 For the orange segments, start with a wide upside down V with the point at the center of the top line. Connect the ends of the V to the top with curved ends.

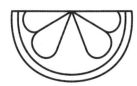

5 Add two more segments inside the first two in the shape of teardrops.

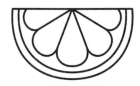

6 Connect the segments with a U shape.

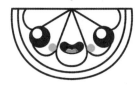

7 Finally, add a face, color, and embellishments.

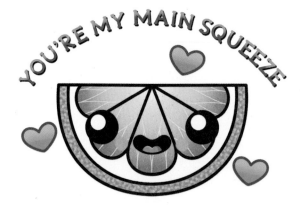

YOU'RE MY MAIN SQUEEZE

Watermelon

1 Start with a triangle with a curved base and a rounded point.

2 Connect a curved line from the top point going down parallel to the right side. Then, connect with a straight line to the base.

3 Below the base, draw a curved line from the left that slightly widens to the right back corner.

4 Next, above the base, draw two curved lines to make a thin strip inside. Do the same with two short, straight lines continuing on the side.

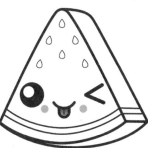

YOU'RE ONE IN A MELON

5 Finally, add a face, color, and embellishments.

Grapes

1 Start with a circle.

2 Draw another circle at the top left, overlapping slightly.

3 Draw another circle slightly above and to the right of the second circle, overlapping the first but behind the second.

4 Draw a circle above the two grapes, overlapping where they meet.

5 Draw another grape behind on the left side, overlapping the one below it.

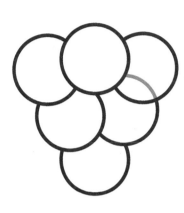

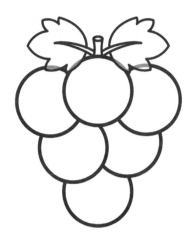

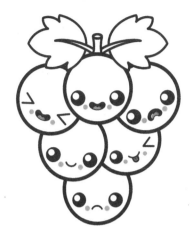

6 Repeat step 5 on the right side of the top grape. Erase any overlapping lines.

7 For the stem, above the top grape draw a thin, short rectangle with an oval connecting the top. Then, draw thin, arched stems extending out on either side. Draw two leaves around the two stems.

8 Finally, add faces, color, and embellishments.

MAKE TODAY GRAPE

DECORATE IT!

GIVE YOUR DESIGNS SOME CHARACTER BY CHANGING THE FACIAL EXPRESSIONS OF EACH GRAPE, ADDING CLOSED EYES WITH HORIZONTAL Vs AND CUTE PINK TONGUES.

Pineapple

1 Starting with the pineapple, draw a slightly flattened circle.

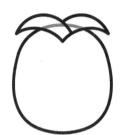

2 At the top of the circle, draw two arches that meet in the middle. Connect the points with two more arches slanting in and meeting at a point. Then, extend the top of the left arch to the bottom right.

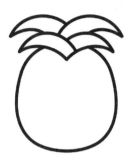

3 Add two longer leaves above, with the overlapping leaf on the other side.

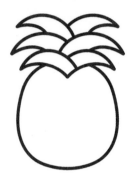

4 Repeat step 3 with two more leaves above, slanting slightly up, alternating the overlapping leaf.

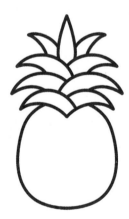

5 For the top leaf, draw a vertical teardrop shape in between the top two leaves. Add a curved leaf on either side, each extending slightly out.

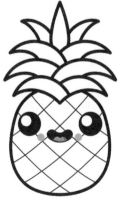

6 Add crosshatching lines on the body of the pineapple. Finally, add a face, color, and embellishments.

I PINE FOR YOU

Cracked Egg

1. Start with the yolk by drawing a small arch.

2. Connect the sides with a slightly curved line.

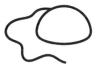

3. For the egg white, start on the left side of the yolk and draw a wavy line extending out and curving in below the yolk.

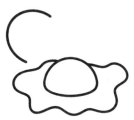

4. Complete the egg white by repeating step 3 but on the right side of the yolk. Then, add a semicircle, slightly slanted above and to the left of the egg, with the opened end facing the yolk.

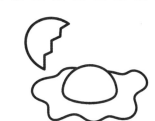

5. Connect the sides of the semicircle with a line with three jagged points.

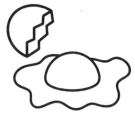

6. Add a second line with inverted jagged points below the first.

7. Draw another, narrower semicircle above the right side of the yolk, mirroring the left one.

YOU'RE EGG-CELLENT

8. Connect the sides with a line with three jagged points. Finally, add a face, color, and embellishments.

Flowerpot 1

1 Draw a thin horizontal oval.

2 To make the pot, below the oval, draw a U shape with a curved line for the base and the sides slightly extending out.

3 Inside the oval, draw a thin curved line following the shape of the top of the oval.

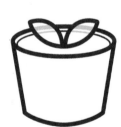

4 In the center of the oval, draw the bottom of a semicircle. Then, connect the sides with two arches meeting in the middle of the semicircle to make two leaves. Erase any overlapping lines.

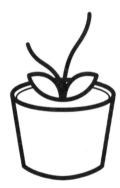

5 From the center of the leaves, draw two wavy lines extending slightly out with the right one longer than the left.

6 Add two leaves on either side of each stem.

7 Time for the flower! Leaving a little space above the right stem, draw a circle. On top of the circle, draw two lines extending out and connecting with a curved line with a dip in the middle for the first petal.

8 Add four more petals around the circle to complete the flower.

9 On top of the shorter stem, draw a rounded V shape, connecting the sides with a curve with a dip in the middle.

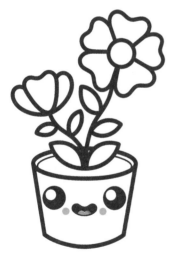

BLOOM WHERE YOU'RE PLANTED

10 Connect a curved line, getting slightly wider at the top on either side of the petal to make the second flower. Finally, add a face, color, and embellishments.

Flowerpot 2

1 Draw a thin horizontal oval.

2 To make the pot, below the oval, draw a U shape with a curved line for the base and the sides slightly extending out.

3 Inside the oval, draw a thin curved line following the top of the oval for an inner rim.

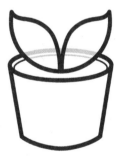

4 Next, make the leaves inside the oval by drawing the bottom of a large semicircle slightly wider than the pot. Then, connect the sides with two arches meeting in the middle, with the ends curved in a point.

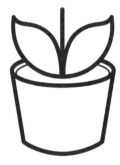

5 Between the leaves, extend a vertical line to just above the leaves.

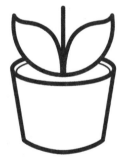

6 A good distance above the vertical line, draw a semicircle and connect the sides with a scalloped line that moves from being short to long on each side.

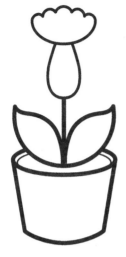

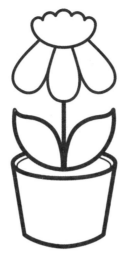

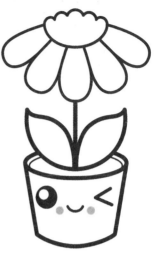

7 Connect to the stem with a long teardrop-shaped petal.

8 Add two more petals on either side of the first, slanting slightly out.

9 Add two more petals on either side of the second petals, slanting slightly out and ending at the edge of the scalloped center. Finally, add a face, color, and embellishments.

GROW WITH THE FLOW

DECORATE IT!

SHADOWS CAN ACCENTUATE ANY DESIGN. FOR A UNIQUE ACCENT, SHADE A DRAMATIC SHADOW WITH A DARKER GREEN IN A SPIKY PATTERN ON THE BOTTOM HALF OF THE LEAVES AND ALONG THE BOTTOM EDGES.

Bumblebee

1 Start with the head by drawing a wide oval.

2 Below the head, draw a jagged line that moves from short to long on each side and connects to the head with curved ends.

3 Add the body by drawing half an oval below the jagged line.

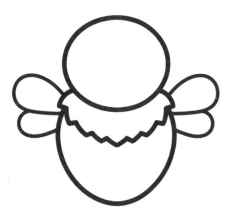

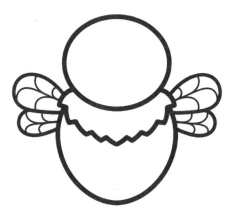

4 For the wings, add two teardrop shapes sticking out on either side of the fur. Draw the top larger than the bottom one and slanted away from each other.

5 Add curved lines from the center inside each wing for detail.

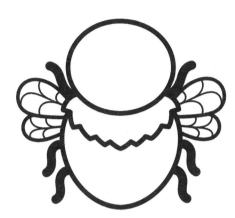

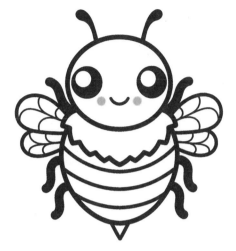

6 Next, the legs. Draw two thick wavy lines extending from the top of the fur and curving out. Then, add two more legs on both sides of the body below the wings and curving out.

7 Add two antennas and a small triangle for a stinger at the bottom of the body. Finally, add a face, color, and embellishments. Don't forget the stripes!

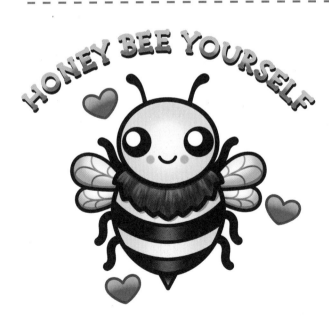

DECORATE IT!

PAINT BRUSHES AREN'T THE ONLY TOOLS THAT CAN CREATE A BRUSHSTROKE EFFECT. ALTERNATE WITH VARYING SHADES OF BLACK, GRAY, AND WHITE IN SINGLE VERTICAL STROKES TO ADD TEXTURE TO THE FUR BENEATH THE BEE'S HEAD.

Garden Gnome

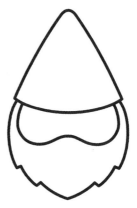

1 Start with the gnome's hat by drawing a triangle with a curved base and a rounded point.

2 Below the hat, draw a curved line. At the bottom, add jagged points—two on the left slanting right and two on the right slanting left—that move from being short to long on each side. Then, inside the beard, draw a smaller semicircle with a single dip in the center.

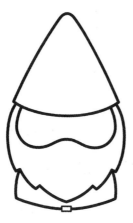

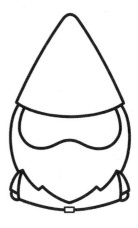

3 For the shirt, draw a curved line just below the tip of the gnome's beard with curved sides. Add a tiny rectangle in the center of the bottom line.

4 Add the gnome's arms with a curved line from the top of the shirt and extending slightly out on either side. Draw semicircles at the end of the shirt sleeves for hands.

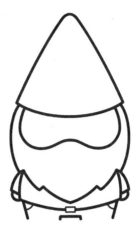 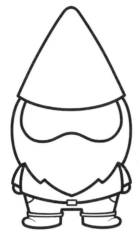 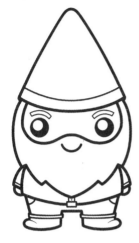

5 Next, the pants. Draw two lines from the bottom of the shirt slanting in. Then, below the tiny rectangle draw the top of a slightly bigger rectangle. Add curved lines at the top corners of the pants for pockets.

6 Complete the pant legs by connecting two thin, slightly wider rectangles. Then, add the feet by drawing a curved line below each pant leg that ends in a curve wider on the outside and a straight line connecting it to the inside of the corresponding pant leg. Draw a thin, curved line to mark the toe of the shoe.

7 Add a curved line above the base of the hat. Finally, add a face, color, and embellishments.

TO GNOME YOU IS TO LOVE YOU

DECORATE IT!

LIKE THE OMBRÉ EFFECT, TRY BLENDING. START WITH A YELLOW ORANGE IN THE CENTER OF THE GNOME'S HAT AND A RED ORANGE AT THE EDGES. BLEND THE TWO WITH AN ORANGE, LIGHTLY SHADING IN THE SPACE BEFORE THEY MEET.

Succulent

1. Starting at the center, draw a tiny triangle with rounded sides.

2. Behind each side of the triangle, draw three more triangles about the same size to create the first layer of leaves.

3. Behind the first layer, draw four bigger leaves.

4. Then, add four more bigger leaves for a third layer.

5. Add two more layers of petals that are the same size as the last layer.

6. In the spaces between the last layer of leaves, add small triangles with rounded sides.

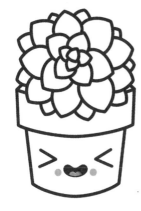

7 For the plant pot, below, draw a rectangle the width of the succulent with a curved top and base. Extend two short lines from the top corners slanted in.

8 Below the rectangle, connect a wide but narrower U shape with a curved line for the base and the sides slightly extending out.

9 Finally, add a face, color, and embellishments.

I AM A SUCCA FOR YOU

DECORATE IT!

SUCCULENTS SOMETIMES COME IN UNBELIEVABLE COLORS. MAKE YOUR OWN NATURAL BEAUTY WITH THE OMBRÉ EFFECT, USING COLORS NEXT TO EACH OTHER IN THE RAINBOW FOR SMOOTH TRANSITIONS.

Aloe Plant

1 Starting with the rim of the pot, draw a rectangle with a curved base and top. Connect two short lines slanting in at the top corners.

2 Below, connect a wide U shape that is narrower with a curved line for the base and the sides slightly extending out.

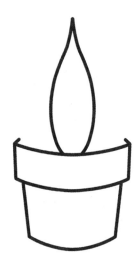

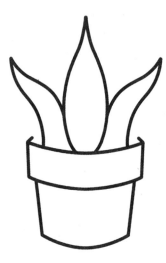

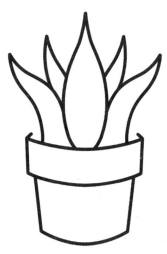

3 Time for the leaves! Start with a tall teardrop shape at the center of the rectangle that narrows into a pointed tip.

4 On either side of the first leaf, draw two more that curve out and are shorter.

5 Between each side leaf, and the central leaf draw two small, horn-like leaves curving inward.

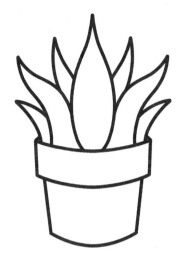

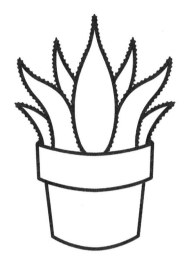

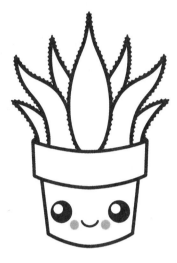

6 Then, fill to the rim with two more small, horn-like leaves curving out.

7 Add spikes along the outline of each leaf by drawing tiny, jagged points.

8 Finally, add a face, color, and embellishments.

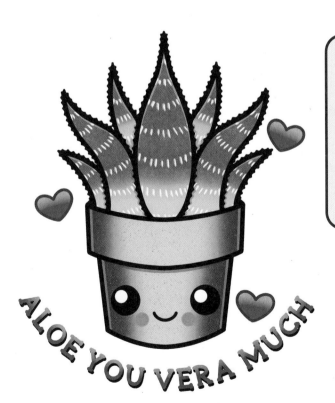

ALOE YOU VERA MUCH

DECORATE IT!

ANOTHER OPPORTUNITY TO USE THE WHITE CRAYON OR COLORED PENCIL IS TO DRAW SHORT LINES ALONG THE LEAVES TO REPRODUCE THIS PLANT'S NATURAL BUT SIMPLE DESIGN.

Cactus

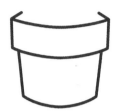

1. Start with the rim of the pot by drawing a rectangle with a curved top and base. Connect two short lines slanting in at the top corners.

2. Below, connect a wide U shape that is narrower with a curved line for the base and the sides slightly extending out.

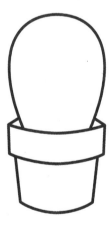

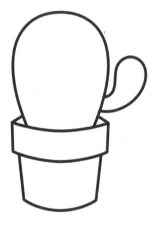

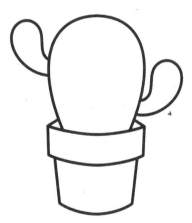

3. Now the cactus! Above the rectangle, draw a bulbous shape that widens at the top. Make it wide enough so that it touches the two short lines forming the rim.

4. At the bottom right side of the cactus, draw a curved line with a bulbous end like an arm that curves back towards the body.

5. Repeat step 4 at the top left of the cactus.

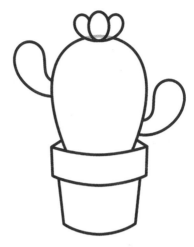 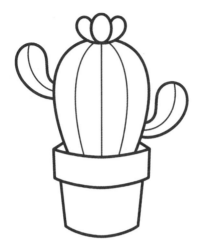 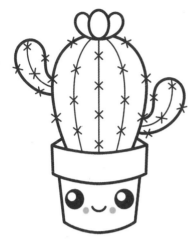

6 At the top of the cactus body, draw a small oval with two ovals connected on either side and extending slightly out.

7 Draw three vertical lines down the body of the cactus, with the two side lines slightly curved. Add a curved line down the center of each cactus arm.

8 Add Xs along the lines and outlines to create the cactus spikes. Finally, add a face, color, and embellishments.

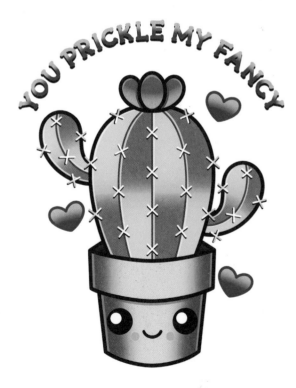

DECORATE IT!

ADD ARTISTIC FLARE WITH A TWIST ON THE BLENDING TECHNIQUE. USING TWO SHADES OF GREEN FROM EACH SIDE OF THE SPECTRUM, ALTERNATE DIRECTIONS GOING FROM LIGHT TO DARK ON EACH SECTION OF THE CACTUS.

Cat

1. Draw the head with a wide oval.

2. Add four jagged points slanting down on either side of the face. Then, draw two pointed arches with a curved line from the point to the head.

3. From the last jagged point on the right side of the face, draw a curved line with three jagged points slanting left.

4. Add a leg with one slightly slanted line and one straight line connecting in a rounded paw.

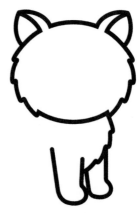

5. Add a second, bigger leg next to the first, with the lines extending up the body.

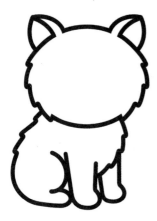 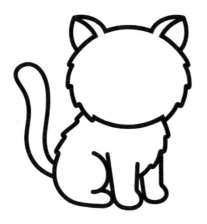 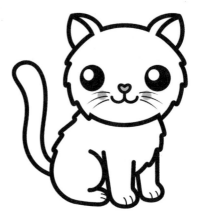

6 From the bottom left of the head, draw a curved line extending slightly out with three jagged points slanting left. Then, curve in the line and create a third paw with a rounded end. Connect a scallop above the height of the second leg.

7 Add the tail with a wavy line coming off the back, extending out and getting wider at the end and narrower at the base.

8 Finally, add a face, color, and embellishments. Don't forget the whiskers!

IT'S MEOW OR NEVER

DECORATE IT!

A KEY TO DRAWING THE BEST WHISKERS IS TO ADJUST THE PRESSURE ON YOUR DRAWING TOOL. START WITH A LITTLE PRESSURE AND EASE UP IN A SMOOTH SWEEPING MOTION, LIFTING YOUR HAND OFF THE PAPER SO THAT THE LINE THINS AT THE END.

Fox

① Draw the head with a wide oval.

② Add three jagged points curving upward on either side of the face. Then, add two pointed arches with a curved line from the point to the head. Erase any overlapping lines.

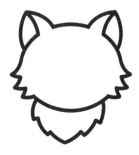

③ Below, connect a curved line with five jagged points, the left two slanting right and the right two slanting left and moving from being short to long on each side.

④ On to the body. From the bottom right of the face, draw a line that extends out and curves into a semicircle. Add two jagged points along the slanted line.

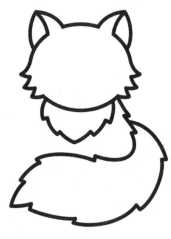

⑤ Draw the tail by continuing the semicircle in a curve going the opposite direction that rounds back around to the jagged line of the fox's back. Add jagged points along the tail following the direction of the curve. Make the tip a sharp point.

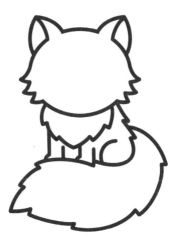

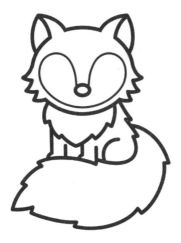

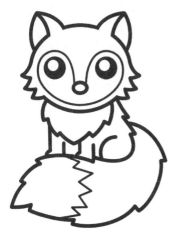

6 Add the legs with four lines between the chest and the tail.

7 To make the face, draw the bottom of a semicircle on the bottom of the face. Then, round the sides in to make two bulbous shapes that connect at a small oval in the center.

8 Finally, add the eyes, a jagged line marking the tip of the tail, color, and embellishments.

YOU'RE SO FOXY

DECORATE IT!

THE FOX LENDS ITSELF NICELY TO THE BLENDING EFFECT. USE BLACK HERE, DARKLY SHADING IN THE EDGES AND CORNERS, THEN USING A LIGHTER HAND TO FADE IT INTO THE NEXT COLOR.

Bird

1. First, draw a light circle for the head. Crossing halfway through the head and slanting left, draw a light, wide oval for the body.

2. Trace a darker line along the top of the head that curves into the body. Then, on the right side of the head, draw a triangle for the beak with the top arched and the bottom curving inward. On the opposite side of the point, draw another triangle slightly shorter.

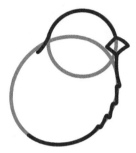

3. From the bottom point of the beak, follow the faint line of the body and curve along the bottom. Add four jagged points for the chest fluff.

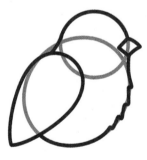

4. For the wing, draw an upside-down teardrop shape with the point slanting to the left and the rounded end connecting to the neck.

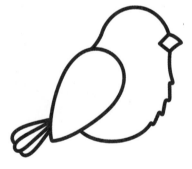

5. Erase the first light lines now. Then, add the tail at the end of the wing with three thin teardrop shapes slanting to the left, with the middle feather slightly longer.

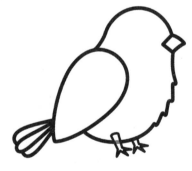

6. Add a foot on the curved bottom of the body with two lines slanted to the right connecting with three points for the toes. Add the left leg behind with the top of the leg ending in a curved line just above the curve of the body.

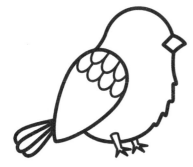

7 Add scallops to the wings starting with three at the top, then a second layer of four below and in between the top three.

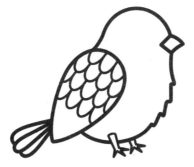

8 Add two more layers of scallops to the wing.

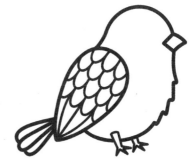

9 Then, fill the bottom of the wing with three lines from between each scallop to the tip of the wing, with the sides curving in. Shade in a small triangle at the tip.

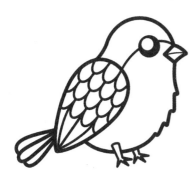

10 Draw a curved line from the top of the beak to the wing. Finally, add an eye, color, and embellishments.

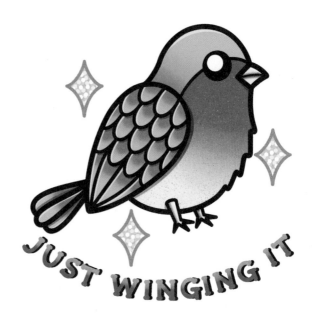

JUST WINGING IT

Bear

1 Draw a circle that is slightly wider at the bottom.

2 Inside the bottom of the circle draw a smaller circle. Then, draw two small semicircles for ears at the top sides of the circle.

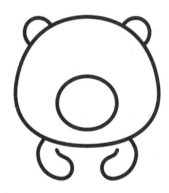

3 For the arms, draw two lines curving in and rounding back to the start on each side without connecting the line back to the head.

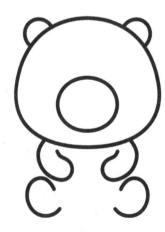

4 Draw the feet just below the hands, and slightly out, with two incomplete circles with the opened sides on the inside of the body.

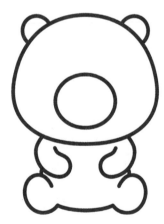

5 Connect the bottom of the feet with a curved line. Then, connect the feet to the body with short, curved lines from the top of the feet to the arms.

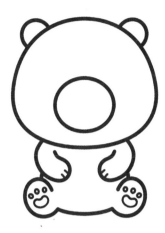

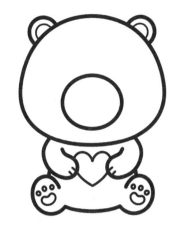

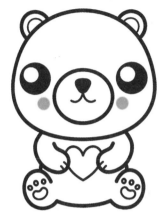

6 Add three circles and a bigger, curved bean-shaped oval on both feet. Then, add two short lines to the ends of the paws for fingers.

7 Draw two smaller semicircles inside the ears and add a heart between the paws.

8 Draw the nose inside the smaller circle as a rounded triangle and shade it in. Draw two curved lines extending from the nose for a smile. Finally, add the eyes, color, and embellishments.

YOU ARE BEARY CUTE

DECORATE IT!

A LACK OF PATTERN CAN MAKE THE BEST PATTERNS. PICK A FEW SHADES OF PINK AND START BY ADDING DOTS OF THE DARKEST SHADE MOVING UP TO THE LIGHTEST SHADE INSIDE OF THE HEART. KEEP THE DOTS THE SAME SIZE, BUT FEEL FREE TO OVERLAP OR GET CLOSE TO THE EDGES.

Snail

1. Start with a circle.

2. Draw a spiral starting in the center of the circle that traces the edge of the circle. Connect the end by curving back into the spiral. Erase any excess lines.

3. From the end of the spiral, draw a curved line up and create a bulbous head to the left. Connect the end by curving back into the spiral. Erase any excess lines.

- -

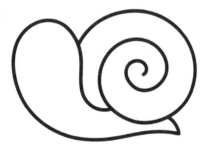

4. Continue the curve of the neck below the shell, getting narrower and ending in a point. Connect with a curve back to the shell.

SNAILED IT

5. Finally, add the antennas, a face, color, and embellishments.

Crab

1 Start with a wide oval for the body.

2 At the middle of both sides, draw two short legs curved down.

3 Add two more legs below the first two on both sides.

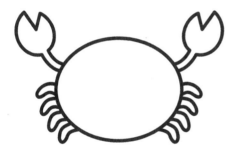

4 For the claws, draw two parallel, curved lines arching up above the topmost legs. Then, connect an incomplete oval with a V-shaped dip at the top for the claw. Make one side of the claw longer than the other.

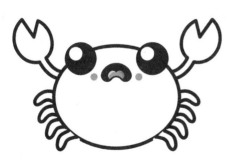

5 Finally, add the eyes, color, and embellishments.

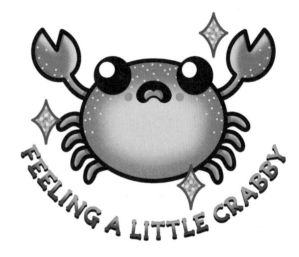

FEELING A LITTLE CRABBY

Narwhal

① Draw a circle, but before closing it, extend the bottom line further out to the right while adding a little curve to the end of the top line, leaving both ends open and parallel to each other.

② At the open end, draw the tail fins with two pointed petal-like shapes facing opposite directions and meeting in the middle of the tail.

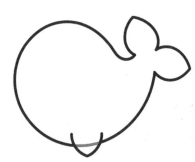

③ Moving to the bottom of the body, draw a small V with curved sides for a fin.

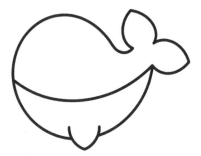

④ Then, draw a curved line from the bottom of the tail to the middle of the left side of the body.

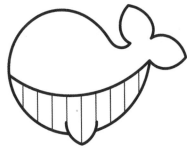

⑤ Draw nine vertical lines from the curved line to the bottom of the body, including through the fin.

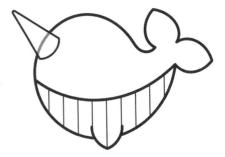

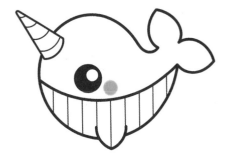

6 For the horn, draw a slanted semicircle at the top left side of the body and extend out into a narrow triangle.

7 Finally, add an eye, color, and embellishments. Don't forget the swirls on the horn!

NARWHAL ALWAYS LOVE YOU

DECORATE IT!

TO ADD SOME COLOR IN ANY LARGE WHITE SPACE, LIGHTLY DASH SOME FLECKS OF THE COLORS ALREADY USED IN THE DESIGN IN A FUN SPLATTER PAINT EFFECT.

Octopus

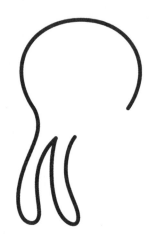

1. Start with an incomplete circle with the bottom left open.

2. With a curved line from the left side of the circle, draw a tentacle curving right.

3. Next to the first, draw a second tentacle with another curved line.

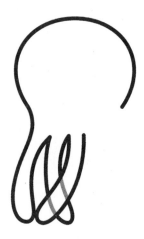

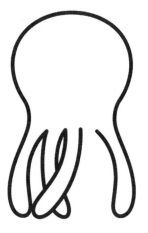

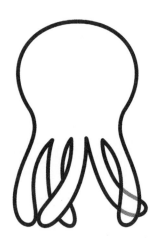

4. For the third tentacle, curve the line to the left, crossing through the second so that it touches the first.

5. On the other side, draw a curved line from the right end of the circle curving left.

6. Draw another tentacle curving to the right in the last space and join it with the other tentacles.

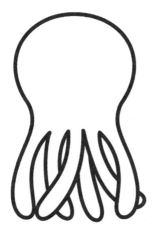

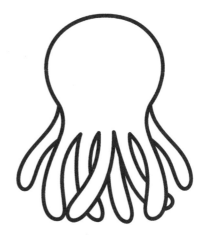

7 Draw another tentacle in the gap between the first four to the left and the two to the right. Erase any overlapping lines.

8 Add two more tentacles on the right and left sides starting where the body curves.

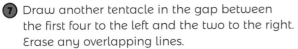

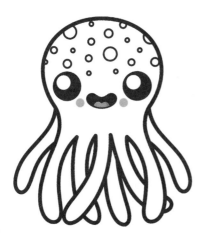

9 Finally, add a face, color, and embellishments.

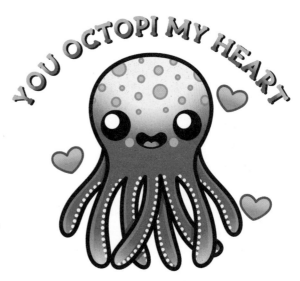

Frog

1. Start with a circle with a slightly wider bottom for the body.

2. Draw two semicircles for the eyes on either side of the top of the head. Erase any inside lines.

3. Next, the legs. Draw a curved line on both sides beneath the eyes. Then, extend out in three jagged points for the toes. Connect to the body with a curved line. Add a short, slanted line in the center of the curve from the body to mark the knee crease.

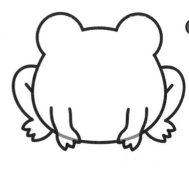

4. Add the arms with two curved lines pointing inward at the bottom of the body. Connect with two curved lines extending wider and connecting with three jagged points to form fingers.

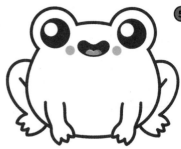

5. Finally, add a face, color, and embellishments.

YOU MAKE ME VERY HOPPY

Thundercloud

 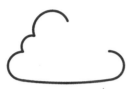 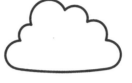 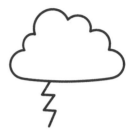

1. Draw a horizontal line with curved ends.

2. From the left, draw two scallops of varying sizes slanting up and moving in.

3. Repeat step two on the right side until the scallops connect.

4. On the bottom left of the cloud, draw a jagged line with three points.

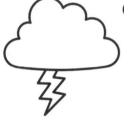

5. Draw the same jagged line a little to the right of the first and connect the bottoms at a point.

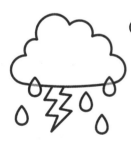

6. Add teardrop-shaped raindrops falling from the cloud.

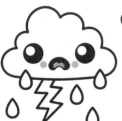

7. Finally, add a face, color, and embellishments.

FOR CRYING OUT CLOUD

Planet

1 Start with a circle.

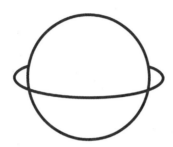

2 Around the middle of the circle, draw a curved line from left to right that is slightly wider.

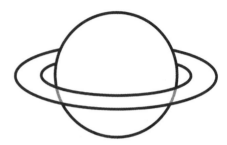

3 Starting higher than the curved line, draw another curved line around the circle to create a ring. Erase any overlapping lines.

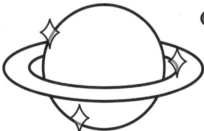

4 Add diamonds with curved sides to create sparkles.

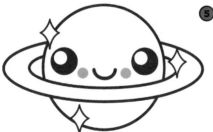

5 Finally, add a face, color, and embellishments.

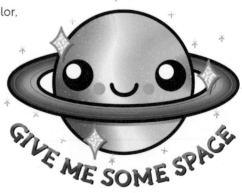

GIVE ME SOME SPACE

Shooting Star

1 From top to bottom, slanting left, draw a curved line.

2 From the bottom of the curved line, draw another curved line slanting up and to the right.

3 Then, connect another curved line to the last line going left and crossing over the first line.

4 Next, connect another curved line slanting down and to the right, crossing over two lines.

5 Connect a last curved line up and slanting slightly to the left until it connects with the start of the first line.

6 Erase the inside lines of the star.

7 Around the right point of the star, draw two lines arching down and connect the ends with a straight line.

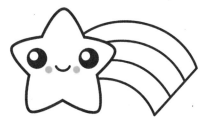

8 Draw two lines inside the arch to create three stripes of equal proportions. Finally, add a face, color, and embellishments.

YOU ARE STELLAR

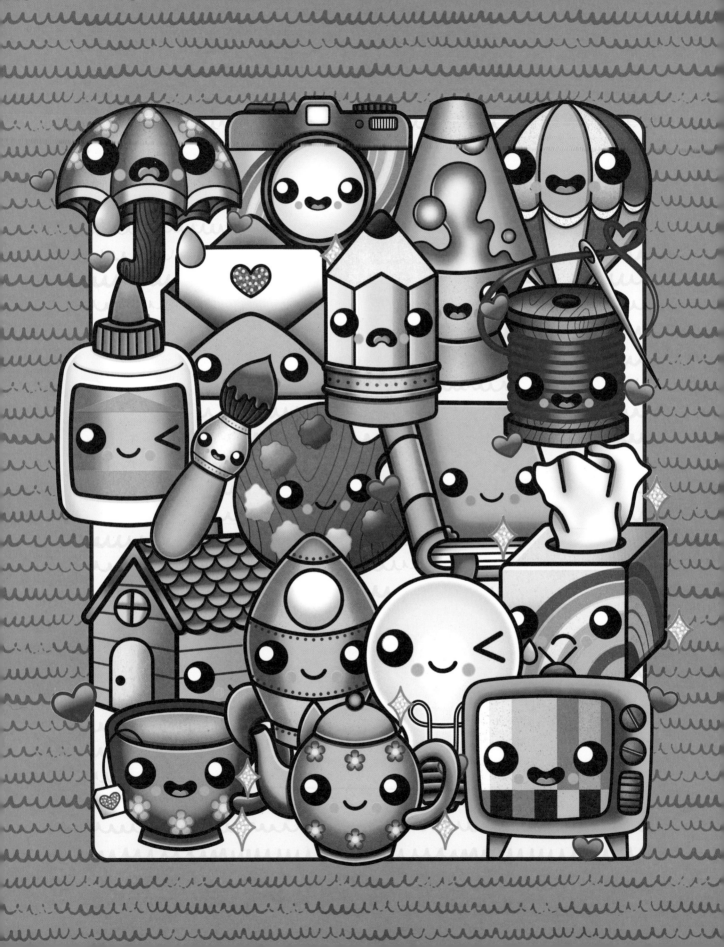

Delightful Doodads

Leather Book

1 Starting with the front cover, draw a rectangle that slightly slants to the left. The slant will help give the book a three-dimensional look.

2 This book has a thick spine, so draw a curved line off the top-left corner of the rectangle, then extend a line down from the left side of the curve, a little past the bottom of the rectangle.

3 Draw a sideways candy cane shape for the base of the spine and book.

4 Close the base of the book on the right side with a C shape, then draw a few horizontal lines to define the pages.

- -

5 This book has a ribbon bookmark, so draw the bottom of the ribbon coming out of the pages with curved parallel lines for the sides and jagged points across the bottom. Erase the page lines from the bookmark.

6 Add two horizontal lines to the spine—these ridged lines are called hubs. Complete the cover by adding decorative metal corners. Draw each of these as the top of a heart shape.

7 Finally, add a face, color, and embellishments.

SORRY, I'M BOOKED

Light Bulb

1. Start with a circle.

2. On the bottom, connect two wavy lines on both sides with the ends slightly curved in.

3. Then, connect the sides with a line with curved ends. Erase any inside lines.

4. Connect the sides with a second line with curved ends.

5. Repeat step 4, making sure each ring has the same thickness. Close the bottom with a slightly curved line.

6. Below, draw two short lines slanting in on each side and connect with a curved line. Below that, connect a short U shape that is narrower with a curved base.

7. With two vertical lines extending up the neck of the bulb, make two opposite loops and connect in a line in the middle. Finally, add a face, color, and embellishments.

I LOVE YOU A WHOLE WATT

1 Begin by drawing the lower half of a square.

2 Add a triangle centered on top.

3 Draw another triangle atop the other one, leaving about ¼" of space between the two.

4 From the upper tip of the triangles, draw a line outwards, then down at a slight right angle.

5 Draw a scalloped line to connect the bottom of the triangles to the slanted line.

6 From the right side of the closed scalloped line, draw another line straight downwards, then a horizontal line to connect the two into a box, creating the outline of the house.

7 Add a small square at the top of the house, just right of the center for the chimney.

8 Draw an upside-down U in the center of the front of the house, then add a small dot for the doorknob.

9 Above the doorknob, draw a circle to represent a window. Draw two intersecting lines centered in the middle of the circle for windowpanes.

10 Fill in the roof with a scalloped pattern of inverted U's with a point at the tops. Finally, add a face, color, and embellishments.

HOME IS WHERE THE HEART IS

DECORATE IT!

SCALLOPING IS A GREAT WAY TO CREATE A PATTERN THAT INDICATES A ROOF WITH TILES. THIS PATTERN ALSO WORKS WELL AS SCALES FOR A FISH OR REPTILE!

Hot-Air Balloon

1 For the balloon, draw a bulbous shape that narrows at the bottom and straightens out.

2 From the top of the balloon to the base, draw two curving vertical lines.

3 Then, add two more lines with a wider curve on each side.

4 Leaving a little space below the balloon, draw a small, narrow U shape with a curved line for the base with the sides slightly extending out to the width of the base of the balloon.

5 Connect the sides with a narrow oval to create the balloon's basket.

6 Next, in the space between the balloon and the basket, draw one line from the middle of the balloon to the front rim of the basket. Add two lines tethered to the sides of the basket and two more in between and slightly slanted in, connecting to the back rim of the basket.

(7) Going back to the balloon, in each section, draw two curved lines, the bottom longer than the top, to form a draping design across the center.

(8) Draw a crosshatch of lines on the basket. Finally, add a face, color, and embellishments.

YOU MAKE MY HEART SOAR

DECORATE IT!

HIGHLIGHT AND SHADOW GO HAND IN HAND IN COLORING. USE WHITE TO HIGHLIGHT THE BOTTOM EDGES OF EACH DIAMOND OF THE CROSSHATCH. THEN, SHADE THE EDGES AND THE INSIDE OF THE BASKET A LITTLE DARKER.

TV Set

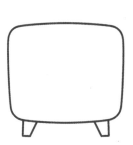
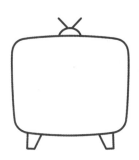

1. Start with a wide rectangle with rounded corners.

2. Add the legs with two short rectangles on the bottom on each side, with the inside line slightly slanted in.

3. To make the antennas, draw the top of a small semicircle on top of the rectangle with two short lines pointing out in a V.

4. Draw the screen with a square inside the tv positioned to the left.

5. In the space on the right side of the screen, draw two circles one beneath the other.

6. Finally, add a face, color, and embellishments.

I WANT YOU TV MINE

Lava Lamp

1. Start with an upside-down V shape with a curved line at the top and the sides extending out.

2. Connect the sides with a curved line. Then, add another curved line inside toward the top of the lamp.

3. Connect a wide, shorter U shape below with a curved bottom and the sides extending out.

4. For the base, draw two lines slanting out from the corners of the U and connect with a curved line.

5. Now, get creative and draw the lava. Inside the lamp, draw a wave with a curving line starting at the base.

6. Add circles and semicircles of lava inside the lamp.

7. Finally, add a face, color, and embellishments.

I LAVA YOU

Camera

(1) Start with a circle for the lens.

(2) Inside, draw a smaller circle to create a thin rim.

(3) Then, around the lens, draw the sides and bottom of a rectangle with rounded corners. Make the bottom line almost touching the bottom of the lens.

(4) Close the top of the rectangle, leaving more space between the lens than at the bottom.

(5) On top of the rectangle, draw the top of a small trapezoid. Erase any inside lines.

(6) Add some details with two horizontal lines inside the camera, going behind the top and bottom of the lens.

7. Back to the trapezoid, add a small square in the space below it.

8. Next, add the buttons on top of the camera with a short rectangle and square on the left, and a rectangle with a curved top on the left. Draw vertical lines in the right rectangle to make a dial.

9. Finally, add a face, color, and embellishments.

FOCUS ON THE GOOD

DECORATE IT!

MAKE YOUR DRAWING EXTRA ADORABLE BY ADDING ELEMENTS LIKE RAINBOWS AND HEARTS.

Umbrella

1. Start by drawing the top of a semicircle.

2. Connect the sides with three scallops.

3. For the handle, draw two straight lines from the center scallop.

4. Finish the handle in a curve pointed to the left in the shape of a J.

5. Back to the umbrella head, starting at the corners, draw five more scallops. The left should slant right, and the right should slant left with the middle scallop positioned directly below the center.

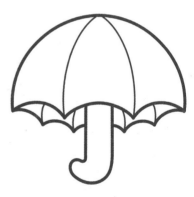

6. Draw curved lines from each point of the scallops to the top of the umbrella.

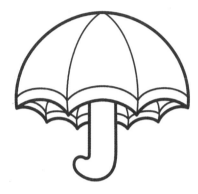

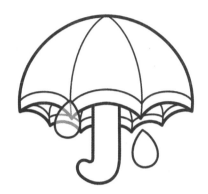

(7) Add another layer of scallops a little bit above the ones already drawn, to make a rim.

(8) Draw two raindrops in the shape of teardrops.

(9) Finally, add a face, color, and embellishments.

WE WILL WEATHER THE WEATHER

DECORATE IT!

WHO DOESN'T LOVE A CUTE, PATTERNED UMBRELLA? START BY DRAWING FIVE CIRCLES SPACED OUT ALONG THE TOP EDGE. THEN ADD FOUR PETALS AROUND EACH CIRCLE SO THAT IT POPS AGAINST THE UMBRELLA.

Rocket Ship

① Draw a vertical football shape for the rocket, leaving the bottom point open.

② Then, connect the sides with a curved line.

③ Below, draw a thin rectangle with a curved base slightly narrower than the body of the rocket.

④ Next, draw a small pointed and narrow oval crossing through the rectangle base and in line with the tip of the rocket. Erase any overlapping lines.

⑤ Draw an arch coming off the bottom of each side of the rocket and curving in. End in a point and connect back to the rocket.

⑥ Then, add three curved horizontal lines equal distances apart along the body of the rocket.

⑦ For a window, draw a circle in the second section of the rocket's body.

⑧ Finally, add a face, color, and embellishments.

I LOVE YOU TO THE MOON AND BACK

Letter

1. First, draw the sides and base of a rectangle with rounded corners.

2. Connect two short, slanted lines facing in at the top corners of the rectangle and coming a third of the way down.

3. To complete the envelope, draw a pointed arch inside the base of the rectangle, making sure to touch the two slanted lines.

4. For the flap, connect a triangular arch on top of the rectangle.

5. To make the letter inside, draw the top of a narrower rectangle starting at the slanted lines and leaving the top arch peeking from behind.

6. Erase any overlapping lines.

7. Finally, add a face, color, and embellishments.

YOU'RE JUST WRITE FOR ME

Teapot

1. Start with a circle.

2. On top, draw a short arch narrower than the circle. Erase any inside lines.

3. Then, make a lid by connecting the sides of the arch with a curved line.

4. Add a small circle for a knob on top of the lid.

5. For the teapot handle, draw two curved lines on the right side, starting at the top and ending just inside the body of the teapot.

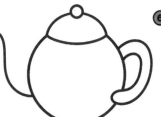

6. On the left side, draw a wavy line curving up and extending slightly out.

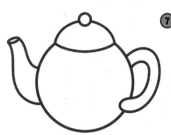

7. Draw a shorter wavy line above the first and connect the two with a thin oval for the spout.

8. Finally, add a face, color, and embellishments.

YOU ARE TEA-RRIFIC

Teacup

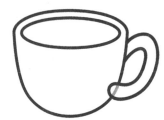

① Start with a wide U shape and the sides slightly extending out.

② Connect the sides with a curved line.

③ Inside the top of the U, draw a thin oval, leaving a thin rim.

④ Next, draw a handle on the right side with two curved lines starting at the top and ending just inside the body of the cup.

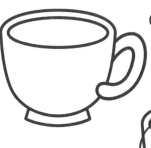

⑤ Below the cup, draw two short lines slanting out and connect with a curved line.

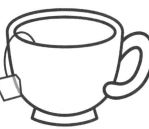

⑥ Add the string of your favorite tea with its tag looping over the edge of the left side of the cup.

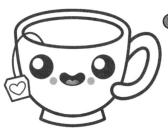

⑦ Finally, add a face, color, and embellishments.

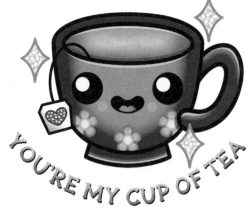

YOU'RE MY CUP OF TEA

Needle and Thread

1 Start the top of the spool with a thin oval.

2 In the center of the oval, draw a smaller oval. Below, draw a thin rectangle with an upward curved base.

3 With a good amount of space below the top of the spool, draw another rectangle with a curved top and bottom.

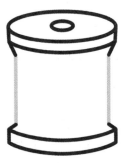

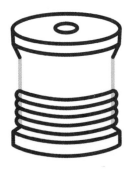

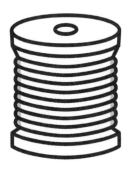

4 At each inner point of the two rectangles, draw one short line slanting in. The top two should slant down with the bottom two slanting up.

5 Next, add the wound thread by starting at the bottom with four thin, curved lines with the ends curved and slightly wider than the slanted lines. Connect the top with a curved line.

6 Complete the spool of thread with four more thin, curved ovals.

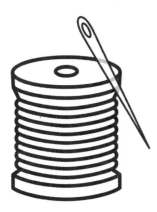

7 Add a needle crossing through the top right corner of the spool. Draw a thin oval slanting down to the right with the bottom narrow and pointed. At the rounded end of the needle, draw a small oval inside.

8 Then, starting on the left, connect a string of thread winding up and looping through the needle hole.

9 Finally, add a face, color, and embellishments.

I'M SEW INTO YOU

DECORATE IT!

OUTLINES HELP DISTINGUISH THE PIECES OF A DRAWING. TO KEEP THE LINES OF THREAD DISTINGUISHABLE, DARKLY OUTLINE EACH IN ITS COLOR WHILE LIGHTLY SHADING INSIDE.

Paint Palette

① Start with a wide oval slightly tilted to the left.

② At the top right, draw a curved dip. Erase any outside lines.

③ To make the thumb hole, draw a slanted oval between the dip and the right side of the palette.

④ Then, along the bottom of the palette and inside the top half of the thumb hole, draw a curved line for dimension.

⑤ Finally, add a face, color, and embellishments.

Paintbrush

1. Start with the handle by drawing a narrow oval with the top unconnected.

2. Connect the sides with a line. Then, on each side, draw two curved lines wider than the handle. Connect the sides with a slightly curved line.

3. On top of that, draw a nice, pointed arch for the paintbrush hair.

4. Then, back to the middle section, add two curved lines near the top and bottom.

5. Finally, add a face, color, and embellishments.

THERE PAINT ANYONE LIKE YOU

Glue

1. Draw the sides and bottom of a rectangle with slightly rounded corners.

2. Then, round the two corners at the open top, leaving a space in between.

3. To make the label, draw a square inside of the rectangle body with a curved top. Leave more space between the square and the top than the bottom.

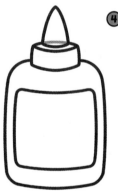

4. To connect the top rounded corners, draw a small rectangle with a curved top and bottom. Then, form a narrow, pointed oval on top of the rectangle by connecting the sides with a curved line. Inside the oval, draw a tall triangle narrower than the rectangle with a curved base. Erase any inside lines.

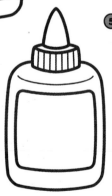

5. Add vertical lines inside the rectangle lid. Then, draw a thin curved line in the space between the lid and the square label.

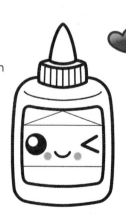

I'M STUCK ON YOU

6. Finally, add a face, color, and embellishments.

Pencil

(1) Draw two parallel, vertical lines a good distance apart.

(2) Then, connect the top with a pointed tip.

(3) On the bottom, connect the sides with a rectangle with the top and bottom slightly curved. For the shorter sides, add a small straight indent in the middle with rounded ends slightly wider than the body of the pencil.

(4) Below, add another rectangle with a curved base the same width as the pencil body.

(5) To make the wood panels of the pencil, starting at the base of the body, draw two vertical lines just short of the height of the sides. Make the middle section wider than the sides. Then, connect a pointed tip on top of the middle section with two slanted lines connecting the side sections to the edges of the body, with the right slanting up to the right and the left slanting up to the left.

(6) Finally, add a face, color, and embellishments.

DON'T BE SKETCHY

Tissue Box

1 Start by drawing a square.

2 Then, connect a line extending from the top left corner. Following the shape of the square, attach a horizontal line that curves down at a ninety-degree angle. Connect to the bottom right corner of the square.

3 Complete the box by connecting the top right corners with a line.

4 Next, in the center of the top square, draw an oval.

5 To add the tissue, start at the corners of the oval and draw two wavy lines extending up. Erase any inside lines.

6 Get creative and use more wavy lines to make a crinkled tissue.

7 Draw a few more wavy lines to finish the tissue. Finally, add a face, color, and embellishments.

I AM CRYING MY BEST

DECORATE IT!

WHEN WORKING WITH SMALL DETAILS OF DIMENSION, DARKEN THE SPOTS WHERE THERE ARE OVERLAPS, BENDS, OR CREASES. THIS WILL ACCENTUATE THE PLACES WHERE SHADOWS OCCUR NATURALLY.

Holidays

Valentine's Day

1 Start with a thin oval slanting down to the left. Add waves to the long sides to make a crust texture.

2 Then, draw a straight line from the bottom of the crust going to the right.

3 Connect a wavy, slanted line to the straight line to the top of the crust to make a triangle.

4 Then, add dripping cheese starting just above the bottom line from crust to point.

5 Make it Valentine themed with heart toppings!

6 Finally, add a face, color, and embellishments.

YOU HAVE A PIZZA MY HEART

Saint Patrick's Day

① Draw a curved line with the ends curving wide down and in.

② Then, draw a small oval inside.

③ Below, connect a slightly wider semicircle with ends that curves into the oval for the body of the pot.

④ On the bottom, draw two small U shapes on each side to make the pot's feet.

⑤ Time for the gold! Inside the oval, draw small disks of coins using an oval and a curved line connected to the bottom.

⑥ Finally, add a face, color, and embellishments. Don't forget the rainbow!

YOU HAVE A HEART OF GOLD

Halloween

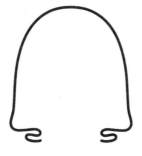

① Start by drawing an arch.

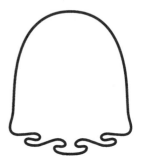

② At the bottom of the left side, connect a line for a rounded corner slightly wider than the arch. Then curve the line back out to halfway before curving it back in to create a wave effect. Repeat the same on the right.

③ Next, connect a wavy line near to the center. Then, curve out for another wave below. Repeat on the other side before connecting together in a line at the bottom.

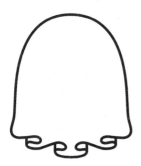

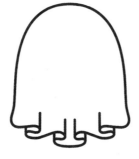

④ Draw short lines from the ends of each curve and connect to the nearest line above.

⑤ Do the same with each inside curve, making short, straight lines going up.

⑥ Then, toward the bottom of the arch, draw a curved line slanting in for the hands. Slant the left hand to the right and the right hand to the left.

⑦ Finally, add a spooky face, color, and embellishments.

Thanksgiving

① Draw a tall, thin oval.

② Then, draw two more ovals slightly behind on either side.

③ Repeat step 2 for a total of 5 ovals.

④ For the stem, draw two short, curved lines slanting in. Start from the top of the back ovals and connect with a thin oval.

⑤ Add one leaf on either side of the stem and a third one in front on the left.

THERE IS ALWAYS PUMPKIN TO BE THANKFUL FOR

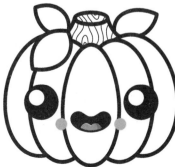

⑥ Finally, add a face, color, and embellishments.

Christmas

① Start with the trunk by drawing a wide U shape with a curved base.

② Above, draw the bottom of a wide triangle with a wavy base.

③ Then, add another triangle on top but slightly narrower.

④ Draw a narrow final triangle on top, leaving the point open.

⑤ In the gap of the top tier, add a star.

⑥ Finally, add a face, color, and embellishments.

HAPPY HOLI-YAYS

DECORATE IT!

WHEN CREATING A GOLD, FLECKED STAR, OUTLINE THE WHITE DOTS WITH GOLD BEFORE GOING BACK AND COLORING IN THE GOLD BACKGROUND. THIS INVERSE COLORING TRICK MAKES FOR A BRIGHT AND COMPLEX PATTERN THAT'S SECRETLY EASY TO RECREATE ANYWHERE.

Mashups

Octopus Planet

1 Start by drawing the top of a semicircle.

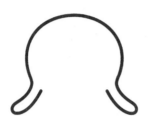

2 Connect two tentacles to the sides with curved lines extending slightly out.

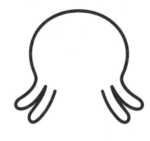

3 Repeat step 2 to add two more tentacles closer inside the body.

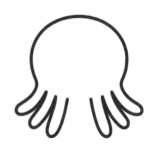

4 Repeat step 3.

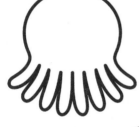

5 Repeat step 3 again so that the tentacles connect.

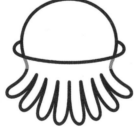

7 Draw another curved line starting above the first to create a ring.

8 Finally, add a face, color, and embellishments.

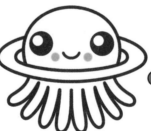

6 Then, around the bottom of the semicircle, draw a slightly wider curved line.

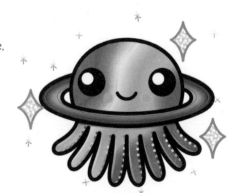

Cat Donut

1. Start with a short, wide arch.

2. Connect the ends with a wavy line of dripping glaze.

3. Then, below, attach an upside-down arch to the glaze.

4. In the center of the glazed top, draw the top of a small semicircle. Connect the sides with a curved line so the ends extend wider.

5. Add two cat ears on top of the donut at each side with pointed arches and a curved line going through it.

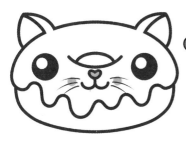

6. Finally, add a face, color, and embellishments.

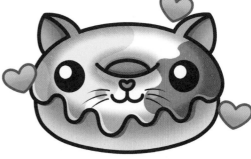

Snail House

1 Draw a bulbous oval, slanted slightly to the left. Leave the left end open but curve the right end up.

2 Complete the snail body by connecting two lines to create a pointed tail on the right.

3 Then, starting on top of the tail and touching the right side of the head, fit a square in the curve of the body.

4 On top of the square add a slightly wider triangle roof.

5 Peeking from behind the left side of the roof, draw a small rectangle chimney.

6 Don't forget the door! Draw a small arch in the bottom center of the house with a dot to mark the doorknob.

(7) Then, add two windows above the door with rectangles with a cross dividing each of them into four smaller rectangles.

(8) Finally, add the snail's face, color, and embellishments.

DECORATE IT!

DON'T BE SCARED TO STEP OUT OF THE BOX AND USE COLORS THAT MAY NOT BE TYPICAL. IF YOU'RE UNSURE HOW TO PAIR COLORS TOGETHER, USE A COLOR WHEEL. THE COLORS OPPOSITE EACH OTHER ON THE WHEEL ARE COMPLEMENTARY, WHICH MEANS THEY GO GREAT TOGETHER.

Cactus Bear

1 Start with a narrow horizontal oval.

2 Below, connect a U shape with a curved line for the base and the sides slightly extending out.

3 Inside the oval, draw the cactus with a bulbous shape. Erase any overlapping lines.

4 Then, add a vertical line down the center of the cactus. Add two curved lines on both sides.

5 Add some texture at the base of the cactus with a scraggly line of soil.

6 Then, draw two short, curved lines from the corner of the oval to the cactus to create the pot's inner rim.

7 Set a small oval on top of the cactus. Draw two more ovals on either side, extending slightly out.

8 Next, add two small arches on each side of the front rim of the pot with two smaller arches inside for the ears.

9 Finally, add the bear's face to the pot, color, and embellishments.

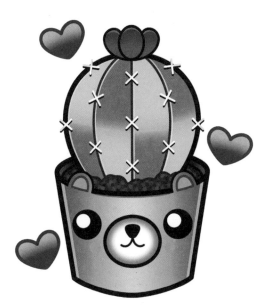

DECORATE IT!

FEEL FREE TO CHANGE THE COLORS COMPARED TO YOUR ORIGINAL DESIGN FOR ANY MASHUP. BUT IF YOU'RE ATTACHED TO YOUR FIRST ATTEMPT, ADDING A FEW, SMALL TOUCHES OF A COMPLEMENTARY COLOR CAN BRING THE TWO ELEMENTS TOGETHER.

Ice Cream Narwhal

1. Draw a circle, but before closing it on the right side, extend the bottom slightly wider and add a small curve at the end of the top. Do not connect.

2. At the open end, draw the tail fins with two pointed petal-like shapes facing opposite directions and meeting at the middle of the tail.

3. Draw a fin coming out of the bottom of the body with a small V with curved sides.

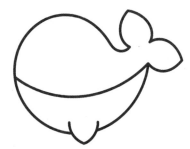

4. Moving on to the belly, draw a curved line from the bottom of the tail to the center of the left side of the body.

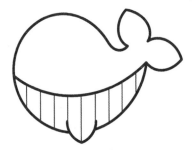

5. Then, add nine vertical lines from the curved line to the base, including through the lower fin.

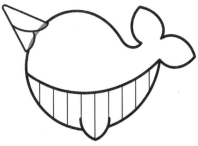

6. Time for the ice cream horn! At the top left side of the body, attach a V with the point slanting left. Then, draw a curved line from the bottom right corner to the center of the left side. Draw a shorter curved line from the left corner to the middle of the first curved line.

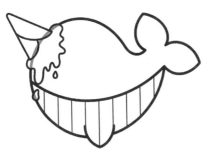

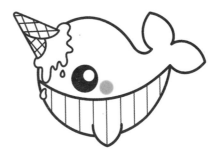

7 Around the base of the horn, draw a wavy blob of melting ice cream.

8 Finally, add the narwhal's face, color, and embellishments.

DECORATE IT!

WHEN ADDING TWO ELEMENTS TOGETHER, TRY SHARING A COLOR BETWEEN THE TWO SO THAT THEY TIE TOGETHER SEAMLESSLY. WHILE YOU'RE AT IT, UTILIZE SIMILAR STYLES OF DETAILING LIKE THE SPECKLES ON THE NARWHAL AND THE SPRINKLES ON THE ICE CREAM.

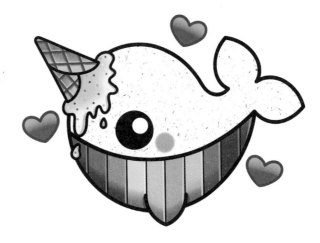

Fox Mushroom

 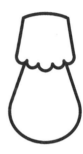

1. Starting with the stem, draw an upside-down U shape with a curved line for the base and the sides slightly extending out.

2. Connect the sides with a scalloped line that moves from being short to long on each side.

3. Complete the stem by drawing a lightbulb shape from the scalloped line.

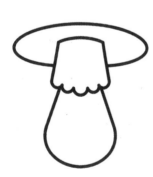 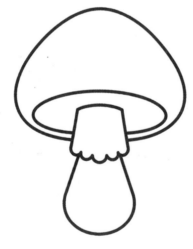 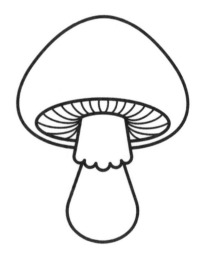

4. Moving on to the cap, draw an oval from the middle of one of the sides of the upper part of the stem to the other side.

5. Starting slightly below the oval, draw a nice bulbous shape for the outer part of the cap.

6. Add curved lines to the oval shape for gills.

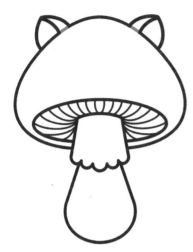

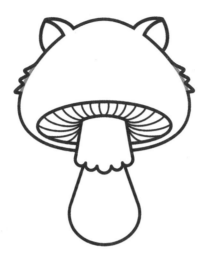

7 At the top of each side of the cap, draw two pointed arches with a curved line from the point to the cap for ears.

8 Then, add three jagged points slanting down each side of the cap.

9 Inside the front of the cap, draw a U shape with each side rounding in a bulbous curve and meeting at a small oval in the center.

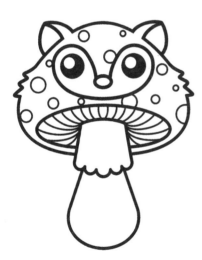

10 Finally, add the fox's face, color, and embellishments.

Frog Umbrella

① Start with the top of a semicircle.

② Connect the sides with three scallops.

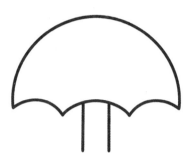

③ Extending from the center scallop, draw two vertical lines.

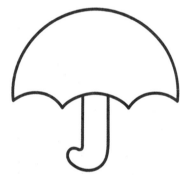

④ Connect the two lines at a curved hook, forming the handle in the shape of a J.

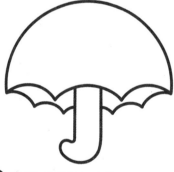

⑤ Then, starting at the corners of the semicircle, draw smaller scallops. The two on the left should slant down and right and the right two should slant down and left, with the center scallop parallel to the top one.

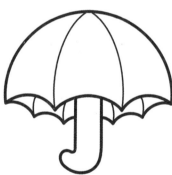

⑥ Add curved lines from each point of a scallop to the top of the umbrella.

(7) Then, above each scallop, draw a curved line to make a rim.

(8) Next, connect two small semicircles on the top of each side of the umbrella.

(9) Finally, add the frog's face, color, and embellishments.

DECORATE IT!

ADDING EMBELLISHMENTS TO YOUR DESIGN ISN'T ALWAYS NECESSARY. DON'T BE AFRAID TO LEAVE SOME AREAS PLAIN. IT'S COMPLETELY YOUR CHOICE WHETHER TO GO OVER THE TOP OR BE MORE SUBTLE IN YOUR CREATIONS.

Gnome Popsicle

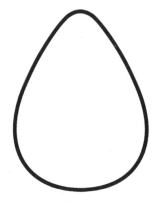

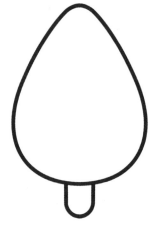

1 Start with the bottom of a semicircle.

2 Connect the sides with a triangle with a slightly rounded point.

3 At the base, attach a narrow U shape for the stick.

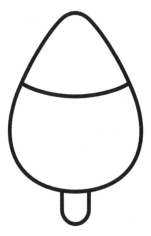

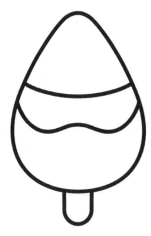

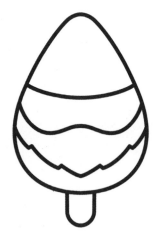

4 Just under halfway from the top, draw a curved line inside the popsicle.

5 Slightly below the curved line, draw another curved line with a dip in the middle.

6 Below the dipped curved line, draw a wide V, adding two jagged points on each side to make a beard.

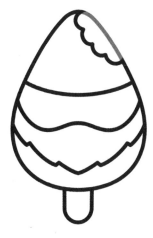

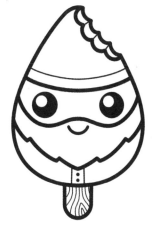

7 Then, at the top right side of the triangle, draw four scallops cutting in for a bite. Erase any outside lines.

8 Complete the bite with another set of shallower scallops above the first. Connect with three lines. Finally, add some shirt buttons, the gnome's face, color, and embellishments.

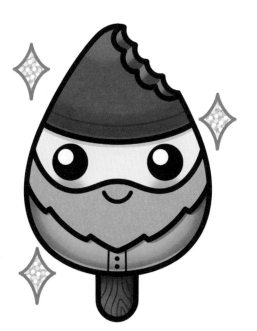

DECORATE IT!

OF COURSE, YOU DON'T HAVE TO BE FANCY WITH YOUR COLORING. COMPLETION OF THE DRAWING IS AN ACCOMPLISHMENT IN ITSELF. WITH BLOCKS OF JUST TWO OR THREE COLORS, YOU CAN STILL COME OUT WITH AN ADORABLE CHARACTER.

Practice & Coloring Pages

Use these characters to try different facial expressions and play with bold colors.

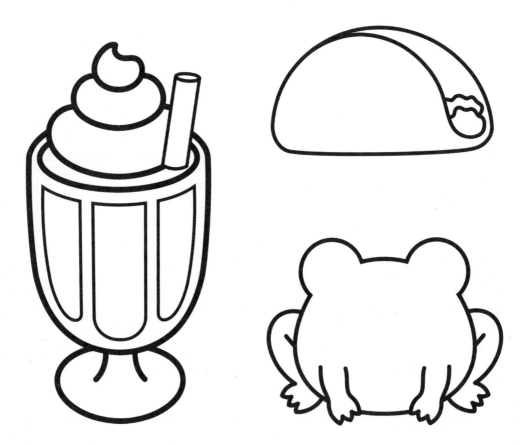

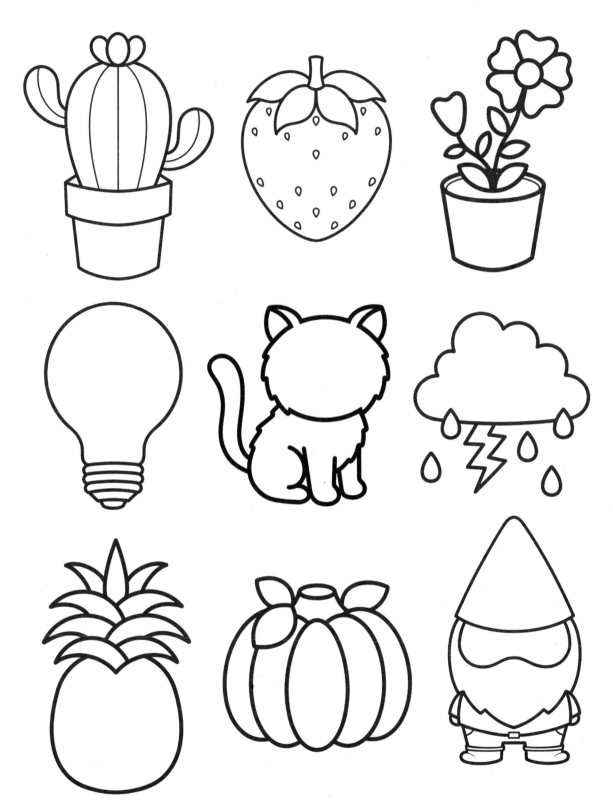

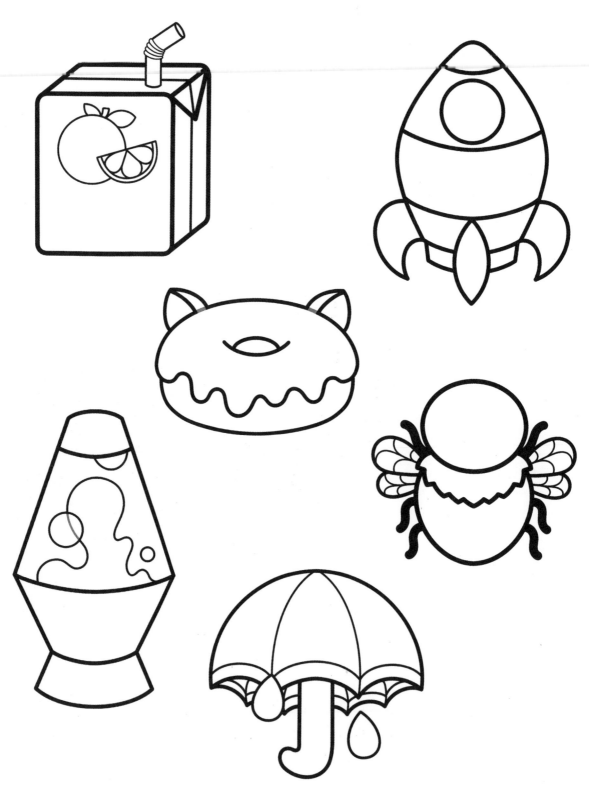

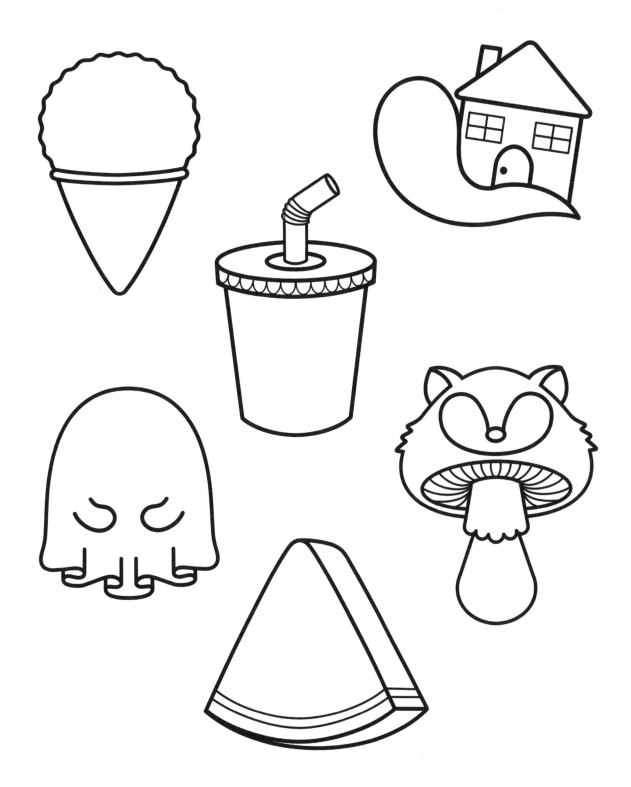

Conclusion

You did it!

Illustration can be seen as intimidating. Once you recognize that you're ready to learn, you've already taken the first step to becoming your own brand of artist! By picking up this book, you've opened a gateway for that wealth of talent within to finally burst out. You've given yourself the tools you need to express yourself through lines, color, and imagination. The possibilities are endless.

There are many important things you must do as you strive to become a fully formed artist, but one of the most crucial things to remember is to never give up! Sure, you may have some setbacks or become discouraged; that's a part of any learning process. I *still* sometimes create a character that just won't turn out the way I envision, or I feel pulled to go back and change colors and concepts. Each time you hit one of these snags, fear not! These moments, no matter how frustrating they can be, are opportunities to hone your own personal style.

Another important part of your journey is that you practice, practice, practice. Each time you master an aspect of illustration, you open the gateway to learning more difficult techniques, which in turn, leads to a higher skill level. The more skills you have, the easier it will be to manifest your imagination on the page. Now that you've worked your way through this book, you're ready to try

a different style or challenge yourself with a higher difficulty level. Pick up another book that strikes your interest, take a class, or even teach someone else what you've learned!

You've come so far, and you should be very proud of yourself. I'm proud of you too! Thanks for taking this journey with me, and I hope you enjoy sharing your newfound inner artist with the world.

Draw from what you've learned and know that you're all that and *pen* some!

Practice, Practice, Practice!

ALSO AVAILABLE:

ANIME ART CLASS

A Complete Course in Drawing Manga Cuties
978-1-63106-764-8

CHIBI ART CLASS

A Complete Course in Drawing Chibi Cuties
and Beasties
978-1-63106-583-5

**CUTE CHIBI MYTHICAL BEASTS
& MAGICAL MONSTERS**

Learn How to Draw Over 60 Enchanting Creatures
978-1-63106-872-0

CUTE CHIBI ANIMALS

Learn How to Draw 75 Cuddly Creatures
978-1-63106-729-7